presented to
Margery N. Wilson
Friends House - E-21
Sandy Spring 20860 Md

Feb. 1969

reviewed by her for the
Friends Journal.

Art and the young child

Art and the young child

Kenneth Jameson

Foreword by George Kaye
Assistant Director of Art Board of Education
New York City

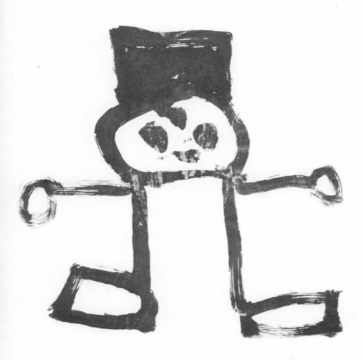

A Studio Book
THE VIKING PRESS
New York

To the children

Published in the U.S.A. by The Viking Press, Inc.
625 Madison Avenue, New York, N.Y. 10022
Library of Congress Catalog Card Number 69–10629
Published in Great Britain by Studio Vista Ltd
Blue Star House, Highgate Hill, London, N19
Set in Lumitype Times 11 on 12 point
Printed and bound in Great Britain by Butler & Tanner Ltd,
Frome and London
Designed by Gillian Greenwood

Contents

Preface

Mr Kenneth Jameson has written a book in which he explains his conception of the art of the young child, and in which he sets guidelines for the teacher and parent to follow to best cultivate this vital means of expression.

Whether a child is in an 'infant school' in a quiet English village, or a kindergarten in a great metropolitan center in the United States, his art work will follow a universal pattern. All children pass through the same stages of growth and development in their drawing, painting and craft work, although there is no predetermined and unvarying standard that will be met at the same age level or in the same period of time. Each child is subject to likes and dislikes; each is affected by the inner world of his mind and the outer world of his environment, and each manifests these individual influences in the results of his art activities.

All children may be harmed by the imposition of adult standards and the use of coloring books and patterns. All children are helped by the unobtrusive guidance of an understanding teacher or parent. It is generally understood that an organized art room or work area in the home can help to provide an atmosphere conducive to efficient working and learning.

The child who is free to paint as he pleases grows in ability and power of self-direction. The child's drawings testify to his instinctive desire to communicate; his crayon becomes a graphic means which is often more expressive and informative than spoken words. The clay which he squeezes, rolls, squashes and smooths gives him great satisfaction and fulfills a definite emotional need. All media serve to give children a means of self-realization – a way of helping to objectify their feelings and ideas.

Mr Jameson speaks with a loud and insistent voice. He cries out quite justly against the abuses of incorrect methodology and warns of potential harm to the child's personality. One may differ with some of his opinions; no one, however, can question his dedication to the cause of art education for *all* children and its role in fostering the personal growth and development of *every* child.

George Kaye
Assistant Director of Art
Board of Education
City of New York

Introduction

This book is an examination in depth of one narrow sector in the field of young children's creative activity. For the experienced teacher of this age group it is by way of a sharing and a comparing of ideas. The experienced teacher will recognise (especially in the illustrations) much that she already knows; discussion of these ideas, it is hoped, may help to bring about consolidation of findings and experience.

For the newer recruits to the ranks of teachers of the young, the book may suggest the framework – the order – beneath the apparent chaos of the child's graphic expression.

For parents, it may provide some understanding of the teacher's aims, purpose and methods. If it can do this it may help well-intentioned parents to avoid some of the popular but harmful influences to which very young children are subjected; painting books and drawing games, for example, and the easy way out of 'Draw me a picture, Mother'.

Is it necessary to teach art to young children – is it possible?

This book is the result of objective study of the drawing and painting of young children. It is based on observation of how they draw and paint and of what they draw and paint, and it attempts to discover why they draw and paint. It considers the implications of their work, and inferences that can be drawn from it. It examines the assessments that can be made. It has as its central theme the function of drawing and painting and creative craft work as aids to the education of young children. Drawing, painting and the crafts are seen as a means and not as an end. What happens to the child as a result of his drawing and painting is seen as of paramount importance; what he produces is regarded as a by-product of the process.

In the pages that follow, an attempt has been made to establish and consider the educational significance of the drawing and painting of young children, and to show that this form of expression is an important starting point for the educational skills – reading, writing and spoken communication.

The views expressed are the result of observation and research in nursery schools (three and a half to five years), primary schools (five to seven years – infant school) and play groups, and the study of children's work in Great Britain and abroad. Discussion with teachers, students and educators from many countries has provided a meeting point for ideas.

The nature of child art is now widely known. Viktor Lowenfeld, Rhoda Kellog, Herbert Read, R. R. Tomlinson and other writers have, in their different ways, helped to inform the public mind about it. Less well understood is the significance of art and crafts in general, as a direct and positive aid to the education of children at every stage in their school career. This book aims to show the application of drawing and painting as a force for education in the context of the school for the young child.

I should like to make one point clear at the beginning. This book deals, in the main, with aspects of graphic art work, drawing and painting. This is deliberate, but it must not be taken to imply that drawing and painting should be thought of separately from creative crafts, or that arts and crafts should be thought of as anything but part of the general activities in the classroom.

They should not; integrated teaching is desirable at any stage of schooling and is, in fact, especially desirable in the school for the young. But at the same time I assert strongly that painting and drawing provide, as no other activity can, special and significant experiences for the young child. They also provide, as no other activity can, at this age, insight into the child's personality and social background, thus enabling the teacher to relate more closely to the child; this is equally revealing to the parent.

Fig. 1 Camilla, aged ten months, investigates a pile of blue paint on a white board. There was no adult influence or persuasion; paint and board were merely placed on the ground and her inborn curiosity drew her to it.

Fig. 2 Camilla, aged twenty months; a pot of paint, a brush and a board with paper were placed on the lawn. No comment was made to her. She had not used (or even seen) brush and paint before. She went straight to the board, picked up the pot of paint in her right hand and the brush in her left, and painted. The photograph shows the work almost finished. It took about twenty seconds. She then painted the metal clips which held the paper in place, and afterwards she spilt some paint on her foot; she then abandoned her painting to go to the bird-bath to wash the paint off her foot. She showed no more interest in painting at that session.

1

2

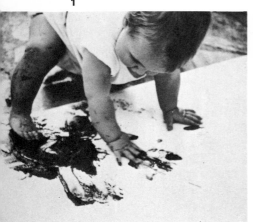
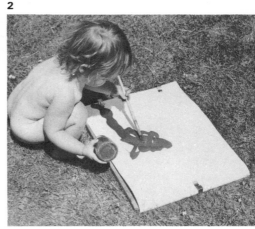

Background

How important is art to the young child? What contribution does it make to his development? What happens when the elementary school child takes his painting home? What can be learnt about the child from his creative art work? What does the child learn from his painting?

From as early as twelve months old and long before they begin to attend primary school, children draw with any medium which comes to hand. At this same time most of them show delight in bright, clear colour. Parents of the lucky ones will provide pencils or other drawing implements, and paper for use at home; fewer, many fewer, will provide brushes and fluid, easily applied, bright paint.

A large majority of children never enjoy the experience of painting and rarely experience the pleasure of drawing in anything but restricted media, before they begin their school lives. The two main causes of this damaging and restrictive state of affairs are:

1 That parents do not understand the educational value of uninfluenced drawing and painting to the development of the child.
2 Limited space and vulnerable furnishings in many homes.

We are fast becoming a world of apartment dwellers. Very often one common living room serves the whole family and the carpet is one on which paint must not be spilt.

It is likely, therefore, that of the children who enter elementary school for the first time (with the exception of the lucky one or two per cent of this age group who go to nursery school, nursery class, or play group first) many will never have had the opportunity to paint or draw.

The very young child naturally and spontaneously lives a life of creative activity. He sings, laughs, dances, builds with bricks, climbs, explores, runs, jumps, loves, draws, paints. Yet of all these natural activities, drawing and painting (probably because they call for equipment and space to work) are the ones which are most frequently denied to the child before he goes to school. And yet perhaps deprivation of this sort is better than the perversion of natural activities which occurs if the wrong kind of equipment is provided unknowingly by loving parents; so-called painting books, for instance.

Parents must be helped to a realisation that children's drawing and painting are not mere crude scribbling and blobbing, but a normal and vital aspect of the child's developing process. It would be helpful if art with a capital 'A' were dissociated from what the children do, and pencil and paint work were thought of as learning activity.

The primary school

The Intake — five- to seven-year-olds

When the school opens its doors at the beginning of the school year it is certain that the new children who pass through and go into the beginning class at the age of five or six will be a very varied group. There is a sad lack of pre-school provision for the 'under fives', an average of just over one per cent in England. A few of them will have been to nursery school, some

3

4

5

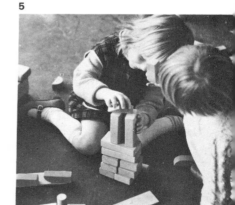

6

7

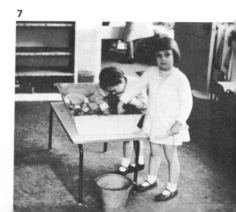

may have attended part-time nursery classes, others will have been to play groups, a minority may have been to private kindergarten, others may be ex-members of day nurseries; but most of them will be arriving new from home and the family circle. In a word, the intake will vary in age, intelligence, in home background and in experience.

It is probably true to say that at this point in a child's school life − his entry into school at the age of five or six − he will enter a community which is likely to be as diverse in composition as any that he will encounter later in life. It is a situation which tests both teacher and child.

With experience, the teacher will be able to deal with this situation. She will recognise the variations in pre-school experience outlined above and will treat the child accordingly. With practice she will be able to discover those children who are already experienced in art; who were given the opportunity to paint and draw and model and cut out, etc., at play group, nursery school, nursery class, playground and at home.

This will mean that some children will have passed through the preliminary stages of drawing and painting, the 'scribble' stage, the 'patch painting' stage, and will be well into the 'symbol' stage before they enter school. These different stages will be dealt with in detail in the chapter on patterns of development. But the majority of other children will never have touched paint and may have had only very restricted opportunity to draw. These latter children will then proceed to work their way through the usual patterns of development, the intelligent ones more quickly than the less intelligent.

In short, this varied group of children will be at widely differing stages of social and aesthetic development, and therefore it becomes a matter of treating each child as an individual member of the class and as an individual performer in paint and line and craft.

By the end of the first year a much greater homogeneity will have been achieved. The children's social integration will be much more complete. The developmental differences in their art work will be far less marked. They will be 'on their way' and will be rapidly and continually adding to their personal basic artistic equipment. New symbols and new conventions will be invented and used to project and communicate and explore their own experiences, not to imitate appearances, not to ape the professional painter, not to paint pictures.

It is the responsibility of the teacher to use every subject in the curriculum and every means her sensitivity can devise to surround the child with the atmosphere and environment which will provide the richest possible experience − visual, aural, tactile, emotional, spiritual, social, cultural. The good teacher will provide an environment which will arouse the child's interest and curiosity, will open his eyes, stir his imagination, stimulate his fantasy and trigger him into creative activity.

In the well-organised primary school the child comes into his own. There he will find bricks to build with, trays with sand to trail fingers through and

discover patterns in, troughs with water to pour and splash, and measure and float things on, blobs of pastry to pinch and poke and shape, clothes to dress up in, stories to hear, beds to rest on, a play house to play in, egg-timers, magnifying glasses, pets to watch and stroke, musical instruments to play, tea sets, playground apparatus to climb up, easels with paints and paper, and fat crayons to draw with: adventure and discovery corners.

Drawing and painting take their place as one of these activities, which are all used together to provide opportunities for the child to explore and find and experiment and experience, to begin the life-long process of educating himself.

The school, the staff and the curriculum all work to one common end; that of educating the child. It therefore follows that the function of drawing and painting as an activity in the school is to help in the process of educating the child. For this function to be fulfilled, the teacher must know the specific and particular educational value of drawing and painting. She must know its application in the classroom situation and must be able to evaluate the art work produced by the children in terms of its educational benefit to the child.

Before proceeding any further it will be necessary to settle the meaning of some basic terms.

Education

By education in the context of the primary school we mean the development and growth of the child, physically, mentally, socially and emotionally. We mean growth in personality through experience; a process of self-fulfilment, achieved by the child for himself, by exploration, by self-discovery, by self-involvement, in emotional, intellectual and sensual experiences. It has been said that 'education is experience made significant'. It is in the area of experience that we can draw from art and craft the maximum educational benefit for the child.

Art

Art is a creative process, a means by which experiences of all kinds are expressed and communicated. It is also a process out of which experience arises. The value of art in the educational process arises from the fact that (1) drawing, painting and creative crafts can provide the child with rich experiences which can be derived from no other source; (2) it provides the child with means of expression – a visual language – for his own personal and social experiences. Experience is an essential of both education and art.

What are the experiences which art can provide for the young child? What are the experiences which he will want to express through his art?

Teaching

The third term which we must agree about is the term teaching, and specifically art teaching. I take this term to mean placing the boys and girls in a teacher-structured classroom situation in which they have the opportunity,

the materials, the equipment, and positive encouragement to engage in drawing, painting, craft work. 'Teaching art' is a misleading term; it is not possible to teach art. It is possible to instruct the pupil in the techniques of painting, or drawing, or print making, embroidery and the rest, but this is not teaching art; this is instruction in skills, and bears as much resemblance to art as teaching handwriting and spelling bears to the composition of poetry.

If a child is placed in a situation where he can spontaneously come to an easel ready equipped with brush, paint and paper and find the thrill of painting bright colour on to paper, this will provide him with a powerful new experience to which he will return again and again, and which he will develop by experiment and repetition. The teacher may never say a word to him, especially at first. He finds this experience for himself because the easel and the paint and the rest are ready and available. In the old-fashioned sense of teaching she has taught him nothing. But she has been responsible for his finding the significant new creative experience of painting. She has set the scene. This is 'art teaching'.

If the teacher is to set the scene in such a way as to use the full and unique educational potential of painting and drawing and creative craft, she must be aware of the nature of this potential.

From observation in schools in England it seems that the training of the teacher in education provides understanding of the value to the child and his development of any and every school situation, except, oddly enough, art situations. Yet perhaps this is hardly surprising considering the diversification in the world of art today. The public mind is bemused about it; the spurious mystique surrounding the artist is all-pervasive. The myth of his divine and exclusive gift and his inevitable death at an early age in a dusty garret is still, in one form or another, unbelievably widespread. Many teachers are in doubt as to how to sort out true values from false, and how to relate art to the primary school situation.

We must clear away these misunderstandings which persist so strongly. 'I simply don't understand art'; 'I can't draw a straight line'; 'I never had any training in art'. Such statements have little or no relevance to art in the lower primary school.

Let us begin by examining how the young child begins, how he develops, and whether there is anything in common between the art of the very young child and the art of the mature professional as we know it in our society.

Patterns of development

Child art is now virtually a household word. The visual 'vocabulary' of the young painter is known and can be recognised by most people. The drawings of very young children are no longer dismissed as meaningless scribbles and blobs, for the significance of the child's graphic expression is now accepted, thanks to the work of Cizek, Viola, Marion Richardson, Herbert Read and others. Yet in spite of this, for various reasons, some misunderstandings still exist about the relevance of creative drawing and painting in the context of the primary school and the educational process.

The aim in the next few chapters is to see whether any light can be thrown upon any of these misunderstandings and whether the close relevance of the graphic arts to the young child in his school can be established.

First, however, let us examine the style, nature and content of the work of the child, from his first patches and squiggles until his mature statements in paint and line when he reaches the age of seven years.

From world-wide studies of young children's art it is clear there are patterns of development which are universal. They apply in Africa, Japan, Tonga, Austria or England. To a remarkable degree, children of every part of the world react in much the same way to paint. If given something to draw with and something to draw on they will discover by themselves, and then use, similar drawn 'symbols'.*

These patterns of development are clearly to be seen in the content of the children's work, in the universality of the symbols they use and the order in which they use them, both of which aspects are surprisingly constant. Let us examine these patterns with the help of illustrations.

Almost all very young children begin by scribbling; the media used are very varied — fingers in food, sticks in dust or sand, steam on the window — but they soon graduate to more positive media like crayon, chalk or pencil — on the blackboard, the wallpaper in the sitting room or, with sympathetic surveillance of parents, on large sketch books or pads. They will continue with this pleasurable scribbling activity, slowly gaining control, until they acquire the power to repeat certain marks and signs and shapes. Study the scribble sequence (figs 8 to 23), noticing the common factor in each of these drawings by one- to three-year-olds. There is an emerging form, a movement towards a shape — an oval. These drawings have been chosen to illustrate the fascinating fact that out of random scribble emerges an order. It emerges because the child *finds* within his scribble a simple shape — the oval — and even more remarkable he finds the muscular control, and the co-ordination of hand and eye, to repeat and reproduce this shape. This is a crucial point in the child's development because, having found the oval, and having developed the power to produce it at will, the child, from that moment, begins to use it. He sees the oval as a symbol which he can manipulate to suit his

* Rhoda Kellogg, *What Children Scribble and Why* (see Further Reading, page 154).

8 Age 13 months. 11×15 in.

9 Age 13 months. 11×15 in.

10 Age 14 months. 11×20 in.

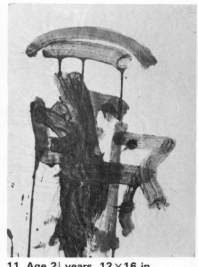

11 Age 2½ years. 12×16 in.

12 Age 3 years. 15×22 in.

13 Age 18 months. 8×12 in.

14 Age 3 years. 6×6 in.

15 Age 16 months. 10×16 in.

16 Age 3 years. Play group. 16×22 in.

17 Age 3 years. Nursery school. 14×18 in.

18 Age 3 years. Play group. 20×26 in.

19 Age 3 years. Play group. 16×16 in.

20 Age 2¾ years. Play group. 20×26 in.

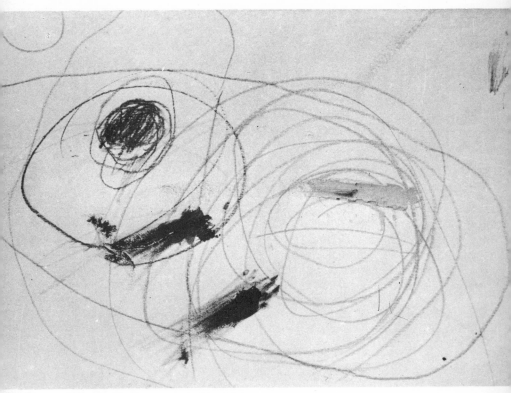

21 Age 4½ years. Nursery school. 22×30 in.

Simon3

22 Age 3 years. Play group. 30×20 in. **23 Age 3 years. Play group. 20×30 in.**

**24 Age 2¾ years.
Nursery school. 18×24 in.**

own ends. Sometimes the oval is said to be a bird, a cat or a house (fig. 27), the addition of lines and dots provides him with limitless permutations, but most frequently it is said to be 'mother' or 'me', with 'mother' by far the most frequent description.

It appears there is firm scientific support for the theory that the face is of prime importance to the infant. Dr René Spitz, the psychologist, has for many years conducted analytic researches in child development. In his book *The First Year of Life* he makes it clear that his researches, and the researches of other workers in the same field, prove that 'during the second month of life the infant is able to segregate and distinguish it [the face] from the background. He invests it with his complete attention.' A little earlier in the text he says '. . . the human face becomes a privileged visual percept, preferred to all other "things" of the infant's environment'.

This discovery of the face/oval at the visual level establishes the unique significance of the oval as the first shape to which the child will respond. Further weight is added to the theory that it is the 'shape' and not the 'person' which evokes the response by the discovery that the child responds to a cardboard mask in exactly the same way as he will respond to mother's face. Not very flattering for mother but an established scientific fact.*

A few months later the child reaches the stage when he can scribble. Quite soon afterwards, no later than two years or just over, he learns to control his scribble. Once again it is the oval which emerges. This seems to be too much of a coincidence for there to be no connection.

* A parallel is to be found in Konrad Lorenz' *The Companion in the Bird's World*, and this is referred to in the *Plowden Report* (see Further Reading). It makes the point that there are certain critical periods in the young child's development when external stimuli, from the environment, make lasting, sometimes lifelong, impressions.

The period of the child's first awareness of his mother's 'face-oval' seems to be one of these critical times.

Fig. 27 A classic example of the 'radial'. This is the first, the archetypal symbol. It is the culmination of the first scribble explorations; lateral scribble, vertical scribble, circulating scribble, the finding of the oval, the isolation of the oval, the elaboration of the oval and finally the changing of the oval into the 'radial' by adding radii. In the context of this book I have used the term 'radial' to indicate the symbol shown in figs 25, 26, 27, 76, 80, 105 and others; i.e. a central, generally oval shape, with radii attached all round. Rhoda Kellogg also uses the word 'radial' in her book *What Children Scribble and Why*, but she uses it to indicate a somewhat different symbol. Readers should note this or a confusion of terminology may arise.

When the child has reached the stage of being able to create a radial at will, he will imbue it with his fantasy. He may call it a man, a bird, a cat. Fig. 27 is said by the child to be a house!

In my experience all children find and use this symbol or a modification of it at the end of the scribble stage.

Look at fig. 27 again, and in imagination remove all the radii except two, close together at the lower edge. Now turn to figs 28 and 29.

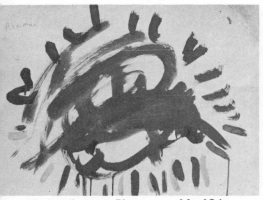

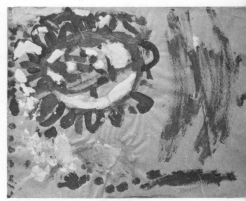

25 Age 3 years. Play group. 14×18 in.

26 Age 4 years. 22×30 in.

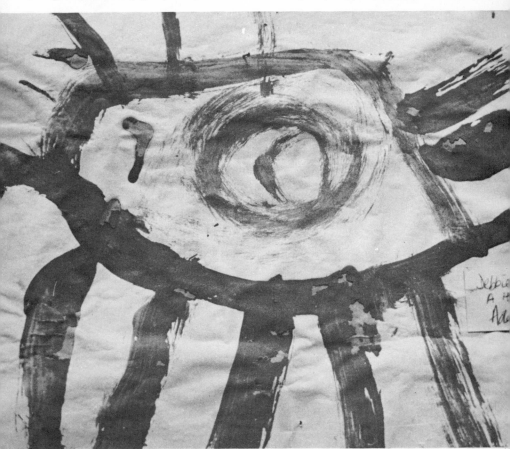

27 Age 3 years.

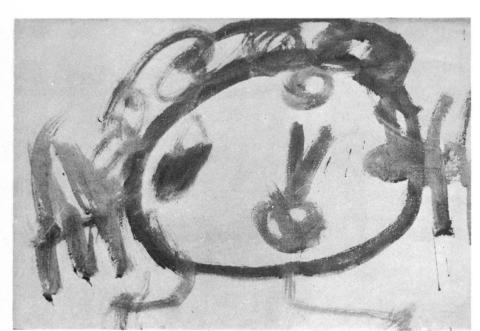

28 The 'oval' with two legs and hand/arms. Age $3\frac{3}{4}$ years. Nursery class. 16×20 in.

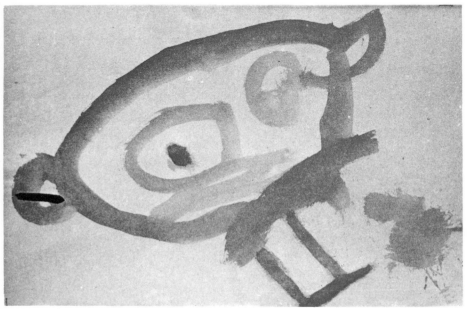

29 Modified 'radial' with two legs and two ears. Age $4\frac{3}{4}$ years. 14×18 in.

Whatever we may deduce from these experiments, we know from observation that some children will find and begin to use the oval 'big head' symbol at thirty months old. Others, as a result of any number of factors, may not reach this stage until five-plus. There is no fixed age, chronological or developmental, at which the child will produce this form of drawing; but in my experience 99.9 per cent of children use it at some stage in their career.

Following on the discovery of the oval, the child will begin to elaborate it by adding dots and perhaps lines. Lines will be added to radiate from the oval. As soon as the child has acquired the power to produce a radial or an oval, recognisable to himself as a symbol, he will begin to use it, to talk to it, to make it act out his own fantasies. What is more, he will be ready to talk about it to his teacher. This is one 'pattern of development'. An experience of *finding* arising out of the act of drawing. It originates in a *drawing* technique. The medium is a drawing medium, crayon, chalk, ball-point pen, felt-tipped pen, pencil and often paint and brush. Little children naturally draw in line. If they are given paint and brush they still *draw*, in line, with them. If a census could be taken it would show that most children are allowed to draw, encouraged to draw (even, alas, shown 'how' to draw), before they begin school, but on the other hand, they are just as likely to be denied opportunity to paint.

Occasionally one encounters prejudice against drawing on the part of teachers of young children. It is sometimes looked upon as a 'throwback to the bad old days'; this view is fallacious, because it is based upon memories of old and now outmoded restrictive practices. Psychologically it is associated with photographic drawing of geometrical solids and plaster casts of items from the human anatomy, with artificial exercises in perspective. This very attitude is the strongest argument for pressing the validity of the modern concept of drawing; that is, its use as a means of expression, and exploration and discovery, as a free and expressive medium in its own right. Its great value is its flexibility and its immediacy. Children draw by instinct; they greatly enjoy drawing. Why stop them? It is time the bogy about drawing being an inhibiting activity was exorcised. Drawing is complementary to painting, not harmful to it.

But this is a digression. Let us return to the child. He is at the stage of having discovered the oval and is beginning to add lines to its perimeter to produce the 'radial' (fig. 27).

Once again study the illustrations and see how the radial gradually assumes greater definition. Dots and lines appear within the oval: gradually they become grouped so as to represent eyes, nose, mouth, and the number of radii diminish until finally there are two, representing legs and sometimes arms. The 'big head' figure is established. The achievement of this figure is a significant stage in every child's development because from now on he will use this figure as a vehicle for playing out his fantasies, stating his experiences, communicating with himself.

The other main pattern of development arises from a more exclusive use

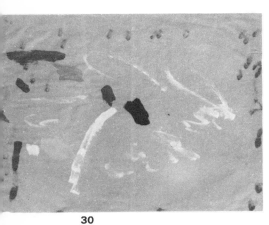

30

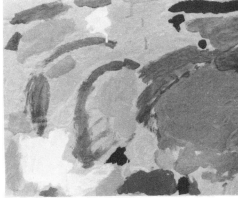

31 Age 4 years. Nursery school. 22×30 in.

32 Age 4 years. Nursery school.
22×30 in.

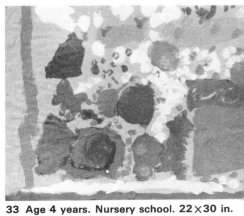

33 Age 4 years. Nursery school. 22×30 in.

34 Age 4 years. Nursery school. 30×22 in.

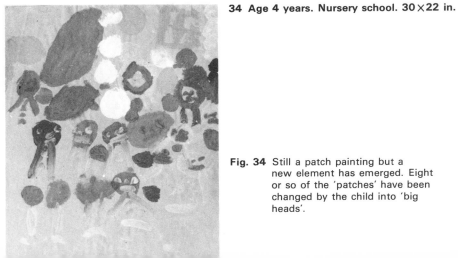

Fig. 34 Still a patch painting but a
new element has emerged. Eight
or so of the 'patches' have been
changed by the child into 'big
heads'.

of one of the media – paint – and it takes a different course, gives rise to more varied expression and is very interesting to observe. Passage through this 'pattern' is likely to take longer and the effects are likely to last longer. In some ways it provides richer experience. It is likely, for most children, that the 'painting' pattern of development will not begin until they start to go to school. It is emphasised that neither of these two patterns necessarily precedes the other. Both may take place simultaneously or may alternate. In some cases painting may come first. An interesting fact which emerges is that both methods very often end up as drawing: drawing as expression, as illustration and used as a language, which in time gives rise to spoken and written language.

Figure 30 shows a typical 'first' attempt at painting by a child in the nursery class and it represents nothing more than evidence that the child has found the easel, the paint, the brush and has discovered that the loaded brush will make marks on the paper. Imagine yourself to be his age again; that you are making this magical discovery for the first time. You find you can create blue by touching the paper with the brush. Put that brush back and take the other brush out of the black pot and you can make black spots appear. If you touch the paper with the wet brush and suddenly move your arm about, keeping the brush in contact with the paper, you find to your amazement that a line appears. You are *drawing*. If you keep the brush on the paper and move it about, gradually enlarging the dot, you get first a spot and then a patch and then a large area; this is painting.

Figures 31 to 34 show the next stage. To have the power to make colour appear from nowhere is exciting. It is a kind of exploring. 'Let's fill the page with patches of colour – different colour.' This is a way of experiencing colour. 'Let's fit the patches of colour close, side by side, so that there are a lot of colours all together.' Skill, co-ordination and conscious choice are needed to do this.

In fig. 32 the patches of colour are made to join each other. Success in accomplishing this with any degree of precision indicates a considerable step forward in co-ordination between eye and hand.

In fig. 33 the four-year-old artist is still using the same basic procedure, but here he achieves another significant, creative, artistic step forward. He uses paint to enrich paint. He uses colour superimposed on colour. This is pure aesthetic activity, producing a work of art which exists in its own right. This is a celebration of colour as colour, a celebration of texture as texture. Before considering fig. 34, refer to the linear pattern of development and recall how after a while the child discovers within his scribble the oval symbol and then the 'big head' symbol for the human figure. This plate shows the precise equivalent in paint. The patches of colour have in eight cases changed into heads to which legs have been added. So emerges the same figure symbol as in the drawings. The wheel has turned full circle. Both patterns have arrived at the same point. At this stage the child needs the human figure symbol most of all; nearly all of his early experiences have to do with people.*

* See *The Psychology of Perception* by M. D. Vernon.

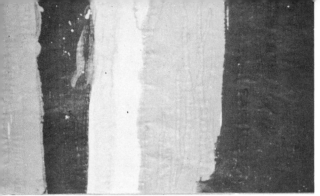

35 Age 5 years. 11 × 15 in.

36

37

38

Fig. 35 Two variations of the 'patch painting' frequently encountered are the 'stripe' and the 'flag' pattern. Figs 35 to 38 illustrate these. Fig. 38 also shows a parallel with the previous 'patch' we looked at (fig. 34), i.e. the emergence of the 'big-head', appearing, as it were, out of the stripes of paint.

Pattern making seems to be inborn in all children. They delight in laying colour beside colour and watching what happens on the paper as they do it. The 'stripe' and the 'flag' soon lead to numerous other variations; the products are rich and varied and are 'abstract' in that they consist only of shape and colour, sensually applied.

39 Age 4¼ years. Nursery school.
24 × 15 in.

40 Age 3¾ years. Nursery school.
12 × 14 in.

Figs 39 and 40 Two versions of the emerging 'big head' figure, typical of the child's first efforts; he is just beginning to sort out the 'big head' symbol from the scribble; he is just discovering how to release the symbol from its background. He is on the point of isolating it so that he can use it.

From now onwards the two patterns of development join and continue in harness together. Sometimes the children's work has a patchwork basis, sometimes a linear quality. Often both appear in the same picture. Examples of all three types at various age levels are given in the plates at the end of the book. Once the 'big head' is established the child tends to isolate it and to use it singly. As may be seen in figs 39 and 40 the embryonic 'big head' struggles free. Irrelevancies are discarded and the figure becomes all important. Figs

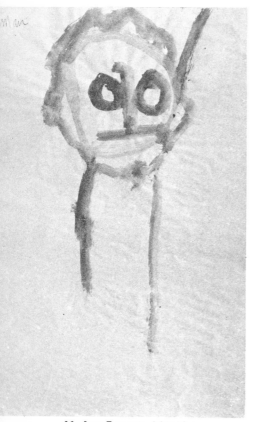

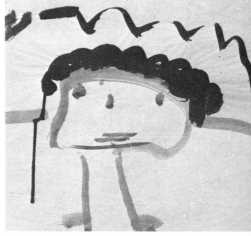

42 Age 5 years. 20 × 15 in.

41 Age 5 years. 14 × 19 in.

Figs 41 to 44 Illustrations of paintings collected from widely scattered districts of Great Britain. They indicate the universality of the 'big head' figure.
 Virtually all children find it and use it. Some of them do so before they are of school age; others much later, i.e. when they are in the beginning class, or at the nursery stage at school.

41 to 44 and 50 to 51 show various versions of the 'big head' figure collected from widely dispersed sources in the British Isles, and illustrate the universality of the symbol. As soon as the child has established control, and can produce this symbol figure at will, he immediately puts it to work for his own purposes and uses it to express events in his own personal life. He paints what he experiences.

43 Age 3½ years. Nursery school. 14×12 in.

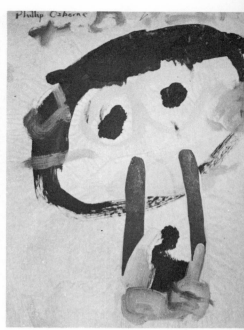

44 Age 3¾ years. Nursery school. 14×10 in.

45 Age 3½ years. Play group. 22×33 in.

46 Is this the effect of mass media?
Age 3¾ years. Play group. 12×14 in.

Fig. 45 A 'big head' with patches'.
The child's version of the content of
'a lady, a walking stick, a bouncing
ball and a dog'.

Fig. 47 Lindy is three years old, Peter
her brother, is five. It was a great
day when Peter went to school for
the first time in his new school cap
with the button on top; here is a
clear example of the way in which
the child will use the simple 'big
head' symbol to express what was
to her a very impressive social
experience.

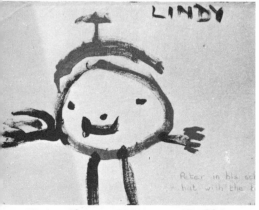

47 Age 3¾ years. Play group. 15×22 in.

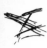

lateral
vertical random
scribble scribble ◄——————————— emerging oval scribble ——————————►

Scribble, line, drawing; progression beginning any time
at, or after twelve months.

PATCH 1 PATCH 2 PATCH 3

Dot, patch, painting; progression beginning at or about three years
and when encountering paint and brush for the first time.

48 Age 4 years.
 Nursery school. 22×15 in.

49 A line drawing in wax crayon.
 Age 4 years. 12×18 in.

50 'Lady with a hat'. Age 4¾ years.
 15×20 in.

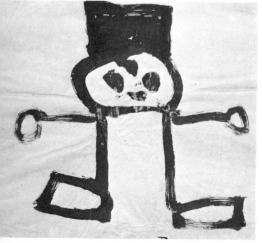

Fig. 48 If the child has reached this
stage he will find the 'big head'
whatever the medium. In this case
he was given a pile of finger paint
on a piece of paper, on a flat
surface. After enjoying the sensual
pleasure of running his fingers
through the slippery paint he
'scribbled' as you see.

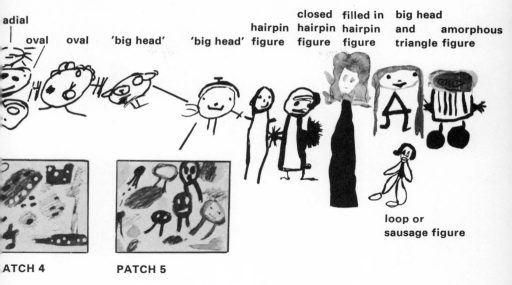

adial

oval oval 'big head' 'big head' closed hairpin figure filled in hairpin figure big head and triangle figure amorphous figure

loop or sausage figure

ATCH 4 PATCH 5

Figs 45, 47 and 50 illustrate some of these events. At this stage the child is not in the least bit interested in imitating the outward appearance of his father or his mother or himself, even if he has the ability. He is *only* interested to relive, or to express, or to develop events which have been, or are, important to him. Questions of proportion, or verisimilitude, are not only unimportant to him, they are meaningless. Any attempt to teach him how to make it 'look right' would be inappropriate, even damaging.

The emergence of the 'big head' human symbol marks the end of the first two parallel patterns of development, in both painting and drawing.

To recapitulate. The scribble development is based upon the line, the patch development is based upon a painting technique. From now onwards most of the children's work will be seen to belong to one or other of these two groups or to display combinations of both: line drawings for quickness and clarity of statement; patch paintings for sensual, luxurious enjoyment of colour.

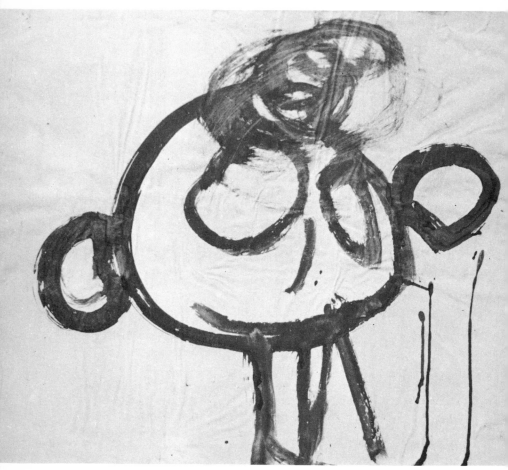

51 The same symbol produced with brush and paint. Age 4¾ years. Nursery school. 15×20 in.

From this point development accelerates. The simple oval 'big head plus two legs' is usually modified by lengthening the two legs, giving the 'hair-pin' figure (fig. 52). It is a simple logical step from that to drawing a line across to join the lower ends of the two legs, thus making a body. Figs 53 to 55 show this in various forms; and so the child reaches a stage when he can produce a human figure with head, body, legs and arms in various assortments and sizes (figs 56 to 63). As with the 'big head', he now proceeds to use the new total figure to make statements about his own personal experiences.

Fig. 52 Typical 'hairpin' figures. These are the next step forward from the 'big head'. In this new symbol the heads are smaller and the legs are longer.

52 Age 5 years. Nursery school. 15×22 in.

Fig. 55 The colour gives the clue to this drawing. The horizontal line at the base of the figure is blue; the rest of the body is drawn in red. This was a typical 'big head' until the blue line was added. So this important new stage is reached by the simple expedient of joining the bottom of the legs and thus producing a body.

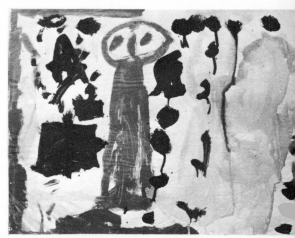

53 A 'filled-in' hairpin figure. Age 4¾ years. Nursery class. 15×22 in.

55 Age 5 years. 30×22 in.

54 A 'filled-in' hairpin figure with 'hair-do'. Age 5 years. Nursery school. 20×15 in.

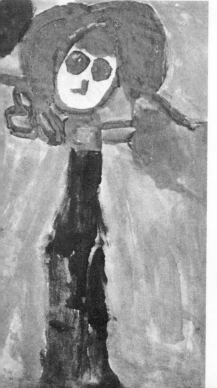

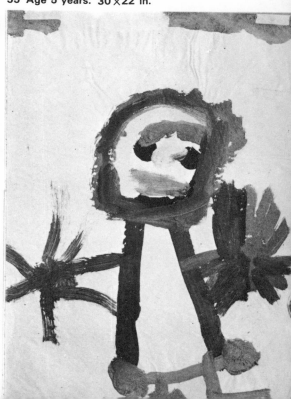

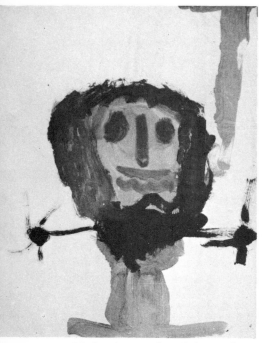

56 Another version of the total human figure. Age 4¾ years. Nursery school. 30×22 in.

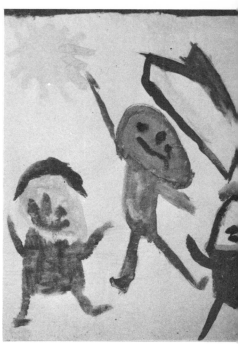

57 'Boys and girls come out to play' (child's title). Age 5 years. 20×15 in.

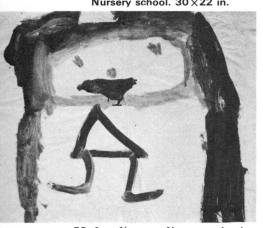

58 Age 4½ years. Nursery school. 20×28 in.

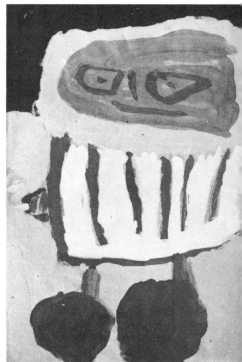

59 'Samuel in the temple'. Age 5 years. 30×22 in.

Fig. 58 'Big head' figure with a typical triangular body added. The point of the picture is the 'hair-do'. Little girls often show great interest in hair styles.

60 Age 3 years. Pre-school. 7×4 in. **61 Age 5 years. 30×22 in.**

"ME"
by Lucy

62 Closed 'hairpin' figure. **63 Age 4 years. Nursery school. 12×12 in.**
Age 5 years. 30×22 in.

Fig. 60 Another of the characteristic versions of the total figure is that composed of 'loops' or 'sausages'.

Fig. 61 The distinction between human and animal is not very clear. By the addition of a minimal tail the human figure becomes a 'cat'.

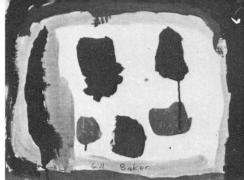

64 Age 3½ years. Play group. 22 × 15 in. **65** Age 4 years. Play group. 15 × 22 in.

66 Age 4 years. Play group. 14 × 18 in. **67** Age 4 years. Play group. 15 × 22 in.

68 Age 4 years. Play group. 15 × 22 in.

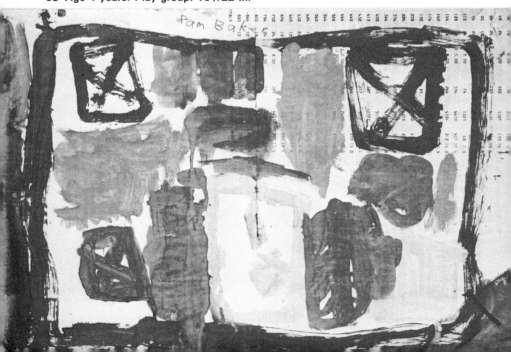

As soon as the figure is firmly established, or even while it is being established, the 'house' becomes important to the child. His parents (the figure) and the place where he lives with his parents are of equal significance to him. Figs 64 to 73 show versions of house/home, and so development continues, though now the pattern of development is less clearly defined. It consists in the adding of new symbols, to embrace the growing and widening experiences of the child in the home, at school, at play, in sport, of the natural world and in fact every sphere in which the child finds himself. We will consider the work of six- and seven-year-old children under a separate heading.

So long as the child needs his symbolistic pictograph language of painting, drawing and modelling for the free expression of his experiences and his fantasy, so long must the teacher respect his need, and if she respects it she must also take seriously what he produces by this means. The teacher should not be in a hurry to suggest things to him; the child will seek help in his own time, sometimes at five or six years, sometimes at seven, sometimes later still. When he asks for help, *then* help him, not before. When you *do* help him, do not solve his problems for him; rather help him to solve his own problems (see 'Sixes and Sevens', page 40).

The child's plea for help is an indication of the stage of his development. Teachers, your knowledge of what he has achieved before he comes to you will help you to evaluate his work and assess his progress.

Fig. 64 As soon as the symbol for the human being is achieved — Mother, Daddy, Me — the child usually proceeds to create an enclosure, a house to put the figure in, a reflection of the importance to the child of his parents and his home. In fig. 64 the embryo house appears out of a 'stripe' painting.
 In fig. 65 the house is produced by the simple device of drawing round the outside edges of the paper.
 In fig. 66 there appears to be a slight confusion between 'house' and 'big head'. This is not uncommon.

Figs 67 and 68 Once established the house quickly gains in complexity. Colour is added (patch painting).

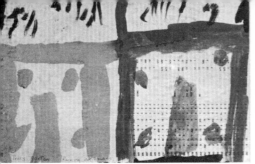

69 More than one house. Rain appears.
Age 4 years. Play group. 15 × 22 in.

70 Age 4 years. Play group. 15 × 22 in.

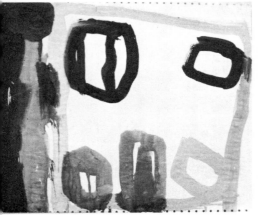

71 Trees are added. Age 4 years.
Play group. 15 × 22 in.

72 Age 5 years. 15 × 22 in.

Fig. 72 The house on wheels; the
caravan. Not at all an uncommon
motif in children's painting these
days.

73 Age 4 years. Play group. 15 × 22 in.

Deviations from the 'pattern'

Influences which bear upon the child will vary from country to country and yet even the deviations from the pattern which these influences produce remain basically the same. Let us consider some of these influences.

Imagine two children aged three. One lives in a home where both parents are artists. Paint and paper and working space are part of the normal environment. The other lives in two furnished rooms with parents whose main interests are television and visiting the local bar. The first child is certain to arrive at school having had considerably more contact with drawing and painting than the second child.

Take two more children aged three. One lives near enough to go to a good nursery school. The other is not so fortunate. Both are children of good, enlightened homes. The first child is likely to enter school with more awareness of art activities than the second.

Take any random group of three-year-old children. Individual members may suffer from physical handicaps, variations in IQ, mental handicaps and various conditions of maladjustment. These must all be taken into account when considering influences which produce variations in the pattern of development.

So home environment, social opportunity and differing degrees of innate ability will produce variants, and these will fall under two main headings.

1 The age at which the child will begin his progress through the patterns of development.

2 The length of time he takes to pass through the patterns of development.

The main variants then are of timing, of speed, of compression and extension; but the pattern, as such, still remains.

Quite frequently children progress to a certain point in the 'pattern of development' and then become obsessed by the aspect of the work which they have reached at that particular point. For example, the child reaches, say, the stage of painting patches of colour and at this point he is obsessively attracted to one special colour. He may then proceed to paint that colour only, all over each paper, time after time. This happens quite frequently and should not be taken too seriously unless it continues for a really long period − several weeks, say. Even then it should only be considered as a matter of concern if it echoes his behaviour in other areas of work in school. It is frequently no more than a release of enthusiasm for colour for its own sake, and sheer enjoyment of it. There is a parallel in language development, when the young child repeats a favourite word over and over again.*

* An example of this was the young boy, aged five, who was taught the name of the flowering bush in his garden, rhododendron. The total word was too much for the boy, so it was broken down into its separate syllables, rho-do-den-dron. This was easy for him. He seized upon the rhythm of the word and repeated it time after time. From the rhythm of the sound he developed a march-dance-game which involved walking round and round the garden chanting 'rho-do-den-dron-rho-do-den-dron', stamping his feet in time to the chanted word and, in the end, beating time with his arms as well.

Another deviation also mentioned elsewhere is encountered at and after the stage where the 'big head' symbol emerges. This will take the form of representing a 'big head' symbol and perhaps other symbols as well, and then obliterating them by painting all over them. This too is common. It is sometimes distressing to teachers because much charming work is destroyed in this way. Teachers can invent subterfuges to rescue exceptional work. If they fail they will feel regret, but they should not feel alarm or concern. This is a safe way for the child to give vent to aggressive tendencies.

A third example is not really a deviation at all and consists of a tendency for the child to 'throw-back'. In other words he may display manifestations of being at differing stages of development at one and the same time. Fig. 74 is a good example of this, showing as it does within the same page four different versions of the human-figure symbol, each belonging to a different developmental level and yet all produced in one session of about fifteen minutes' painting by one child. This does not mean regression. It most probably means progressive deterioration of concentration as the child went on with the work. It may be an indication of the characteristic 'ebb and flow' of children's learning at this stage. Who doesn't get fed up with things, anyway? Fig. 75 shows examples of 'big heads' and complete figures: a pair of drawings showing different stages of development included in drawings produced virtually at the same time. It shows drawings of their teachers by two children in the same age group (nursery), which represent vastly differing abilities.

To sum up this section, having passed through these two patterns of development the child will have acquired a personal acquaintance with colour, a primitive but practical symbol language enabling him to make statements about himself and his world, and enough knowledge of basic media and materials to enable him to give full reign to his imagination and his fantasy. The stage is set for growth and development in the light of experience.

Drawing is discovery.
Painting is pleasurable experience.

Fig. 74 This drawing of four figures was made, by a child of four years, in about ten minutes. The extremely primitive 'big head' represents 'mother'. The picture is a clear example of a child performing at different levels at one point in time.

Fig. 75 Two different children in the same nursery class draw their teachers. The children are the same age but are at different stages in drawing ability.

74 Age 4 years. 22×30 in.

75 Nursery school. 10×20 in.

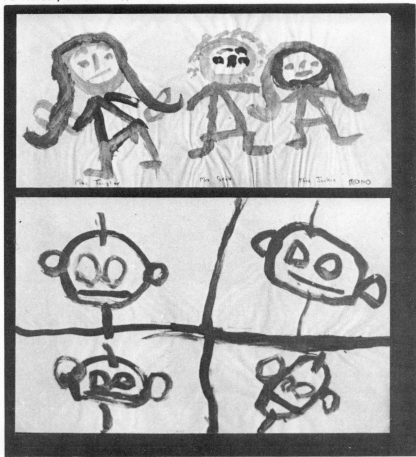

Sixes and sevens

The chapter heading is apt, whether taken at its face value or metaphorically. It accurately describes a state of non-homogeneity of developmental level and of performance at this age.

At this stage there will be much variety in the manifestations of drawing and painting. All the same, there are certain guide lines. Perhaps we can best approach the matter by asking ourselves the following questions:

How does the work of seven-year-olds differ from that of five-year-olds?

Should it be possible to recognise work as being that of an older child, or of a child of a higher development level? If so, how?

In what way do children develop from five to six and from six to seven?

Is one likely to meet different art situations in the classroom as between, say, the younger and the older children?

What forms are they likely to take?

Are there any special teaching techniques which will help one to meet the needs of the maturer child?

Let us take these questions as a group. As children grow through the fifth year they begin to be much more aware of their environment. In the same way that they *found* and then *used* the 'big head' they now add new symbols to their visual vocabulary and use them for expression; the 'strip sky' (fig. 77), the 'strip of ground', the 'box house'. The familiar radial is now used for 'flower heads' and 'suns'. In figs 77 and 79 the tree appears. The characteristics remain, namely lack of proportion, absence of local colour. At this stage children make no attempt to *imitate* what they see; the child invents and uses new simple symbols and he uses these symbols as vehicles of expression. At seven, children will be making illustrated diaries and work books, and the drawings will be progressively richer and more complex. They reflect the child's growing capacity to absorb many more experiences and then to translate these into forms of expression and communication. At this mature stage children retain and develop their appreciation of paint as paint; of colour as colour. Look at fig. 83. I watched this picture from the first touch to the completed work. The little girl, aged seven, worked all morning on it, off and on. She *loved* that colour, and the luxurious laying of paint in patches on the paper. This, after all, is a logical extension of the 'patch painting' progression we studied earlier in the book. What a luxurious painting this is. *Note:* part of its richness is brought about by the teacher's care to see that the paint is clean and richly mixed; it would be impossible for the child to produce painting like this with weak, watery paint.

A difference which seems to exist between younger and older children's painting is that the younger ones (except for the odd dab at each other's work) tend to work as individuals, whereas the older ones seem to work more readily together at group work. Perhaps it is because the younger child is more egocentric, more solitary, that he tends to ignore other children when he paints. He rarely seems to talk to his friend working at the next easel; but, by about seven years of age, there is a tendency towards what is best described as parallel behaviour and working together.

76 Age 4 years. Nursery school. 14×10 in.

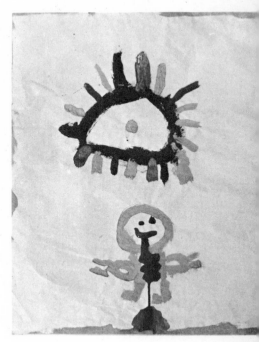

77 Age 5 years. 15×22 in.

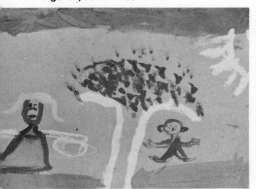

78 Age 4 years. Play group. 15×22 in.

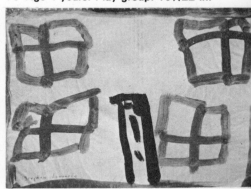

79 Age 5 years. 15×22 in.

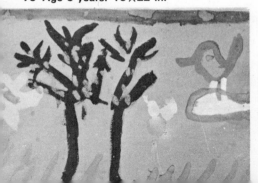

80 Age 5 years. 17×27 in.

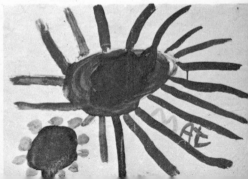

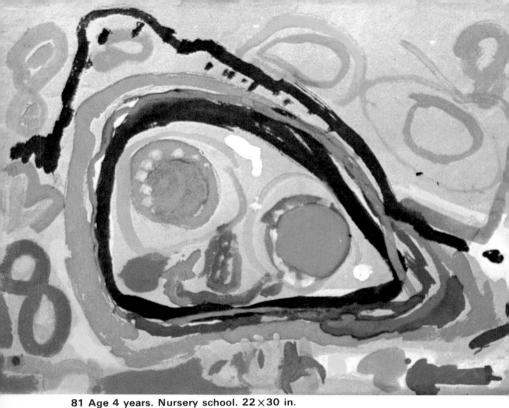

81 Age 4 years. Nursery school. 22 × 30 in.

Fig. 82 When a child naturally makes a bird like this it is wicked to cause him to change to the inexpressive symbol we, alas, know so well.

82

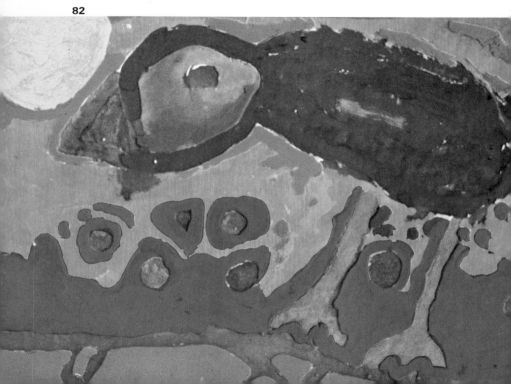

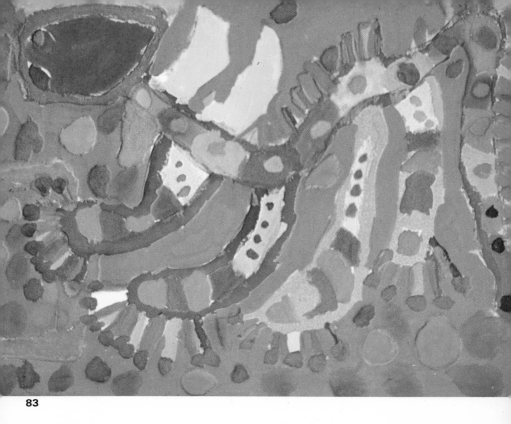

83

Fig. 83 This picture is a logical development from 'patch painting'. The content is almost negligible. Sensual delight in colour and in the feel of paint are evident. The seven-year-old girl who painted this picture spent most of the morning on the work, between periods of doing other things.

Fig. 84 The little girl who drew this was aged three years nine months. She sat down to the kitchen table with paint brush and paper, unaware that her mother was

84 Age 3¾ years. Pre-school. 15 × 22 in.

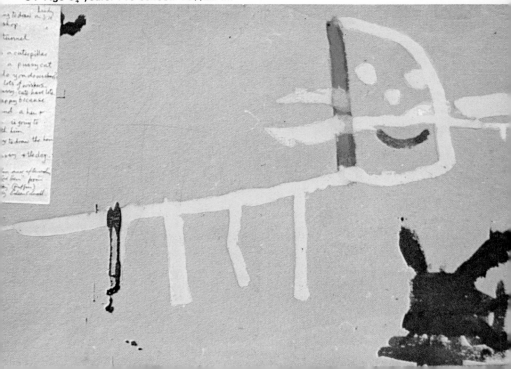

standing by listening, with paper and pencil in hand, ready to write down any-
thing the child said.

The painting began with the dark straight line of the head. 'I'm going to
draw a fish shop,' she said. Then she drew the curved line of the head saying,
'It's a tunnel' (her little brother has a toy train with a model tunnel that shape).
Next she drew the line which joins the lower points of the first two lines, and
continued onwards to the left; in a dreamy sing-song voice she chanted as
she went, 'This is a caterpillar.' There was then a sudden change of voice and
emphasis as the four 'down' lines were added to the long transverse line; 'No,
it's a pussy-cat.' The child was using a thick brush and a puzzled look pre-
ceded the next step. 'How do you do whiskers?'; her brush was thick,
whiskers are thin. Suddenly she had a bright idea, 'I'll do lots of whiskers,
'cos pussy-cats have lots.' The next step was to add features. As she drew in
the smiling mouth she said, 'He's happy because he's found a hen; and the
hen is going to live with him. I'm going to draw the hen, the pussy and the
dog.'

The child's commentary was noted down verbatim by mother at the time;
the original of this was then stuck to the top left corner of the paper, un-
happily obscuring the dog.

This is a classic case of the developing drawing suggesting ideas, recalling
memories of past experiences as it proceeds; and of the memories and ideas
in turn modifying the progress of the drawing. The unexpected arrival of the
hen in the commentary is explained by the bedtime story of that time – 'The
Little Red Hen'. The fish shop resulted from memories of a favourite shopping
outing.

A good deal of descriptive speech came out of this exercise, and the pro-
cess of 'feedback' is seen at work; i.e. the marks on the paper suggesting
ideas to the child's imagination, and the imagination in turn prompting the
modification of the marks, resulting in new marks which start the process all
over again.

When this child was confronted with the drawing some weeks later she
could not or would not remember anything about the story and showed no
interest in her work.

Fig. 85 Page from the 'diary' of a six-year-old child. Compare this drawing with
Lindy's drawing of Peter in his school cap (fig. 47). An enlightening compari-
son between the performance of a child of three and that of a child of six
years. The day and date were copied by the child. The sentence was written
by the teacher at the request of the child.

Figs 86 and 87 Some of the most expressive of all the work produced by infants is
the graphic work in their 'work books' or 'diaries'. Two examples are illus-
trated here. Both the children show very good ability in drawing and painting.
The girl has a strong sense of colour and the boy has a facility in descriptive
drawing.

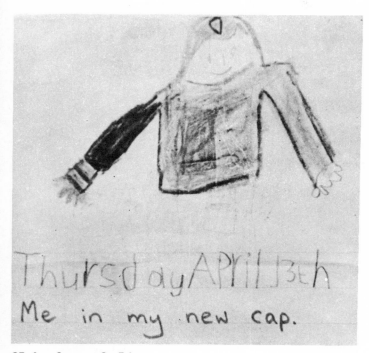

Thursday April 13th
Me in my new cap.

85 Age 6 years. 8×5 in.

86 By a girl, age 6 years. 8×6 in.　　87 By a boy, age 7 years. 8×6 in.

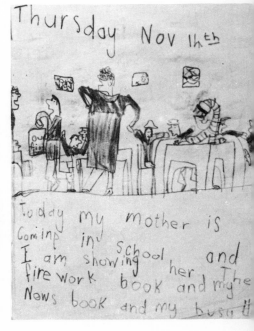

Thursday Nov 1h th
Today my mother is coming in school and I am showing her The fire work book and my News book and my busi

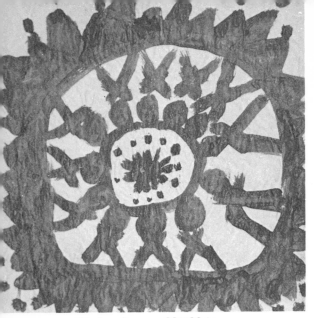

88 Age 6 years. 22×22 in.

89 Age 7 years. 30×22 in.

90 Age 7 years. 30×22 in.

91 Age 6 years. 22×30 in.

92 Age 6 years. 22 × 30 in.

Fig. 92 The child asked the teacher to write the following against this picture: 'We are at the seaside. I swam in the water with my boat. There were crabs in the water. There were butterflies round me. I was sitting near a shell. The caravan was on the beach. It was blue.'

93 'A picture about Sunday'. Age 6 years. 22 × 28 in.

94 Age 6 years. 12 × 20 in.

95 'Mother cooking'. Age 6 years.
10 × 6 in.

96 'The fair'. Age 7 years.
22 × 30 in.

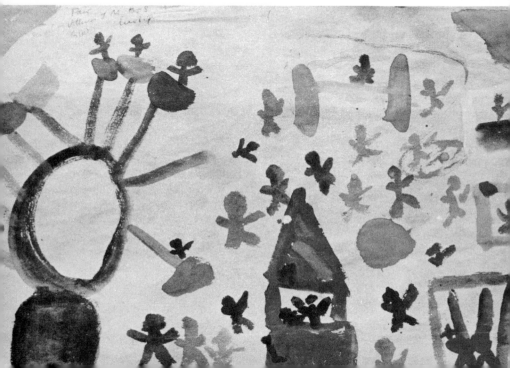

There is no doubt that new teaching situations will arise in the seven-year groups. For instance, there will be growing signs that the children are beginning to be more self-critical; they will be dissatisfied with their drawings and paintings. This is a situation which must be met by the teacher. 'This doesn't look right – how can I make it look right?'

When this stage of critical self-awareness has been reached, *and not before*, the teacher should help in every way possible. Sometimes the solution can be found by merely persuading the child to persist a little longer in the direction in which he was going. He might be urged to look, to feel, to smell: to explore his surroundings more fully; to think. The teacher can ask him leading questions. She should expect the child to concentrate for longer periods on what he is doing. At this stage the child will relish more of a challenge. I have watched seven-year-old children working with great success at screen printing, block printing, lino cutting, wood carving and other sophisticated art crafts. We must learn never to underestimate the capabilities of the child, especially the child of seven years old.

Another fairly general characteristic of the child's passage through the age span of the primary school (elementary school) is that the older he grows the less spontaneous he becomes in his ability to start to paint or draw. 'What shall I draw?' is symptomatic.

97 98

Figs 97 and 98 Seven-year-old children using sharp lino-cutting tools. They produce work of high quality. The boy above is printing a string block which he has made.

99

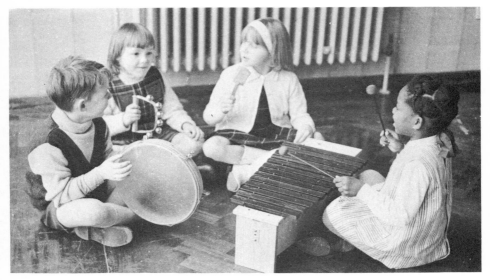

100 Children exploring musical instruments and inventing music together.

At the top end of the primary school it may well be that some, if not all, of the children will need a stimulus to start them painting or drawing, though if their experiences are rich enough it is not so likely. I remember the visit of Coco the clown to talk about road safety to the children. He wore full regalia: red nose, big boots, baggy trousers, everything! I also remember the resulting paintings – such clowns as you never saw, bursting from the seven-year-old children as a direct result of their excited experience of Coco – a direct visual stimulus. Try dressing-up one of the children and use this as visual stimulus. Bring stuffed birds into the classroom, or flowers. By asking questions, lead the children to look at trees, skies, houses, each other. *Help* them to look and then *leave* them to paint.

Stories, music and movement, the nature walk, all can serve as 'starters' for painting. But take care that stimulation does not become dictation.

One final word: some schools in England now practise the family grouping system, i.e. as children enter the school they are placed with one 'family' group, with one teacher, and they remain in that group throughout their whole stay in the school. This means that at any given time there will be children of five, six and seven years of age all in the one family-group class.

I have questioned teachers and observed children in this situation and find that their art work is not greatly affected. The gradual progress from scribble to sophisticated seven-year-old is much the same. Occasionally a situation arises when, because of pressures within the classroom, the older children, being more responsible, are left to 'get on with it' by themselves, and when this happens the children tend to take the line of least effort and to stop work too soon. The work then does not reach the standard of what we know to be the norm of seven-year-old performance. This seems to support the thesis that at the top end of the primary school more individual attention is required, more leading, more inducing of usable experience. Experience is the spur for every kind of expression and especially for painting and drawing. Visual stimulus leads to identification with environment and this is the logical link in preparation for the impending move into the next level of school at the age of seven.

Creative activity

Drawing, painting and crafts are one aspect of the creative activity which forms part of the environment of any normal primary school (five to seven years). The others are familiar: dressing-up, acting, singing, making up stories, imaginative play, movement, dancing, building with bricks, climbing, running, jumping, shouting, tending pets, looking at things, feeling things, picking things up, breaking things, exploring musical instruments . . .

If a child enters an environment which contains picture books, dressing-up clothes, play house, building blocks, climbing apparatus, if he is stimulated by the sound of rhythmical music, he will (without any prompting) involve himself spontaneously in some, perhaps all of these activities. This spontaneity is significant. Some children may need to be prompted into action, then, once started, if they are left alone they will continue spontaneously. It is sad that an increasing number of very young children coming into schools have to be prompted into creative action of this kind. Is this the fault of mass media? Is it denial of companionship with friends of their own age range because of the isolation imposed on children who live in apartments?

If this kind of spontaneous creative activity is given free range and encouraged in childhood, it may well lead to the development in the child of that personal creativity which in turn leads to enrichment of adult life by spontaneous creativity of greater variety and more advanced kinds,* collecting, photography, boating, physical culture, budding rose trees, growing tomatoes, writing poetry, painting pictures, dress-making, embroidery, amateur dramatics and operatics . . .

But to return to the child: in taking part in diverse activities he learns, he is not *taught*, he learns by experience. He learns to associate with others, to come to terms with them, with himself, with physical problems, to make calculations and judgements and choices. He in fact educates himself spontaneously. So what is the role of the teacher if the child teaches himself? The teacher is subtly in control of the whole process, by making sure that the dressing-up clothes, the play house, the bricks, the climbing apparatus, the water, the clay, the sand, conversation and the many other things that go to make up a rich environment are there. She supplies the paints, the paper, the easels, the big crayons, the pieces of wood and cardboard, the tubes of glue, the cotton, the bits of cloth, the string. She is there to lead children into safe environments full of excitements: gardens, parks, streams, insects, plants, stones, walls, woods and fields outside the classroom and school.

We must now pass on from discussing the nature of creative activities to an attempt to see *how* these activities arise; what starts them off.

The process begins in the mind of the child — in his imagination. Creative activity is a direct product of the child's imagination. Let us take a typical example. The child finds himself beside the dressing-up box. A hat attracts his attention. He pauses, eyeing the hat; he picks it up, turns it round in his

* See *Child Art* by W. Viola.

101 Age 4 years. Nursery class. 16×24 in.

Fig. 101 This painting contains a 'big head' figure and other symbols. All of them, with the exception of the 'big head', have been deliberately obliterated by the child.

hands, examining it. It is a highly coloured hat with extravagant decoration. He sees himself in it; he is a prince, a clown, he is important, he is ten feet tall. He places the hat on his head and as he does so he takes on a new personality. He enters a new world of fantasy. This is elementary primitive drama. To the bystander there is something to see that was not there before – a little drama – brought to creation by the imagination of the young child, imagination sparked off by the visual impact of the hat.

Another example. The child finds a collection of building bricks. He picks up one brick, perhaps stands it on end. The sight of this standing brick starts his imagination working. He sees, or imagines, a lofty building. He adds more bricks on top, it grows and he inhabits it. The building has grown from the child's imagination. It was not there before; he has created it.

Another example, more relevant to our theme. The child is given a brush, paint and paper. As soon as he discovers that to dip the brush and apply it to the paper produces a mark, his imagination takes over. He will continue to make mark after mark for the sheer joy of it. The patterns of marks he produces will spring from his imagination.

If a child were brought up in isolation, with none of these things in his environment, serious deprivation would be the result. Unhappily many children are deprived to a greater or lesser degree.

Creative activity begins as a stroke of imagination. It may be direct or it may be induced. In other words it may arise directly, spontaneously, out of the child's imaginings, or it may begin as a result of something he sees – the hat; or hears – the music; or feels – such as clay. In either case what happens afterwards, the play, the song, the dance, the model, the painting, the drawing, arises from his imagination and develops in communication with his continuing imaginative, fantasy state.

Not all creative imaginings result in constructive activity. Very frequently children will destroy what they make. This tendency is to be seen in every classroom. An example of an obliterated painting is shown in fig. 101. Processes of imaginative thought go into the destroying of a work, as well as into the making. Teachers should not worry if work is destroyed by the child.

D

The child who paints a picture and then obliterates it, or makes a clay model and then squashes it, or builds a high tower of bricks and demolishes it, is finding a harmless outlet for his normal aggressive instincts. This situation is not only acceptable, it is to be welcomed.

On the other hand the parallel in adult behaviour produces an unacceptable situation. It needs creative imagination to think out a plan of social service, of help to old people. It is also creative imagination which projects the idea of beating up an old man. Creative activity as we know it, on the individual, national and international level, is of two kinds, constructive and destructive. It certainly is so with the young child. Adolescent delinquency is a direct result of the diversion of creative energy from constructive to destructive channels.

In the context of the primary school we think of activities as being the sort of activities listed at the beginning of this section by which the children learn and develop. We think of these as creative activities. This is a general term which we apply to the imaginative play and experience of children. Drawing and painting are a part of these activities – a special part. The act of painting for five- to seven-year-old children is creative play; from it they gain special experiences which are obtainable from no other source. How better to experience colour, for example, than to create large areas of colour by applying paint to paper with a big brush. Similar vital experience stems from drawing and the crafts.

Drawing and painting are the infant creative activities which have the most powerful feed-back. By feed-back I mean that what happens on the paper stimulates the child to further imagining and new creative activity.

The creative process

How does a painter produce a picture? The superficial answer is he takes a brush, dips it into paint and applies the paint to the canvas. What starts him off? What sparks off the creative process? Let us look for example at a well-known painting by a famous artist – Van Gogh. Imagine Van Gogh standing in that cornfield in the south of France. The burning yellow sun blazes down upon the golden corn. A hot breeze stirs the tall stalks. Van Gogh, sensitive to yellow of any kind, to warmth and to light, is so violently affected by the scene that he throws chrome yellows, cadmiums and ochres on to his canvas in a feverish attempt to express the intense feelings he himself experiences. He strives to express in visual terms his excitement about the gold corn, the sun, the heat. Sixty-five years later that same canvas, hanging on the wall of an English art gallery, rolls back the years, spans the distance between Arles and London and still radiates the golden yellow heat that compelled Van Gogh to take his brush, to dip into the paint and to apply the paint to the canvas.

102 'Cornfield with Cypresses' by Vincent van Gogh. June 1889. Oil on canvas, 28½×36 in. National Gallery, London.

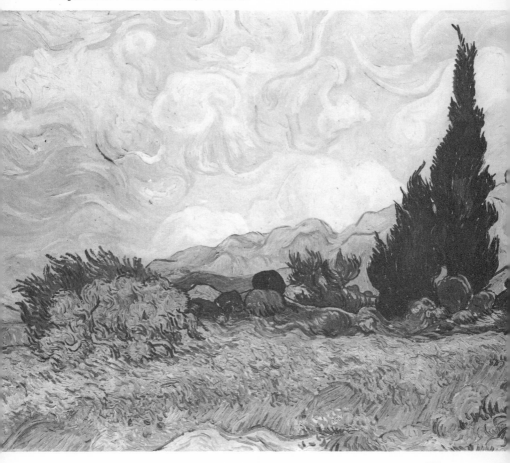

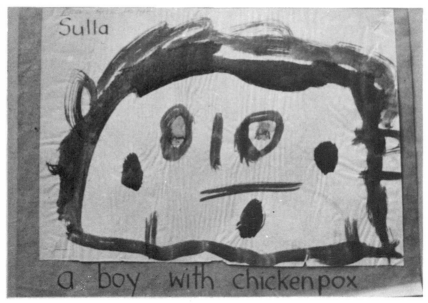

103 Age 4 years. Nursery school. 15×22 in.

The visual and emotional *experience* of the cornfield started the creative process and relentlessly drove Van Gogh to *express* his experience in such powerful terms that an impression of the original experience is *communicated* to the viewer even today! Experience, expression, communication; these are fundamental to the creative process, and experience is the 'trigger'.

The example chosen above shows a professional work of art produced as a result of an experience which was in the main visual, but this is *only one* starting-off place. There are many others — emotional, spiritual, intellectual, sensual, physical, social. No two artists begin from the same experience. Experience is personal — so personal that we can read from a painting a good deal of information about the artist's personality. *Cornfield with Cypresses* is the reflection of an intense personal experience.

The work of very young children is equally, if not more, explicit. It is also less complicated and more direct. It follows certain broad patterns of development, which are apparent to the sensitive observer of their work. The five- or seven-year-old has his own personal way of working in paint and line, which still conforms to the wider overall general pattern of development. It should not be necessary to affirm here that young children paint and draw like young children and not like small adults who are not very good at it! The first task of the teacher is to learn what the appropriate and natural mode of expression of the young artist looks like. Let us consider a typical example and see whether there are any points of similarity between Van Gogh's painting and the work of the young child.

The portrait illustrated (fig. 103) is a drawing with brush and paint. It is a typical 'big head' drawing by a young child. The title indicates the nature of the experience which played a great part in triggering off this work of art. The expression of the idea is powerful, direct and simple. It is a complete and clear statement. We must remember that at this age the child would be unable to express himself in writing. Yet his expression of experience, in

terms of drawing, is prolific. The value of this form of expression is recognised by teachers and is used as an aid in assessing the development of the child. In the present drawing the expression is effective and communicates the nature of the original experience to the viewer, to the teacher. Experience, expression, communication, the same three basic components as in the case of Van Gogh.

Young children from the earliest age communicate continuously with themselves and with others by means of drawing, and I contend that the creative process in the adult professional is virtually the same as that in the child. Experience is the trigger in both cases, and in both cases expression follows experience. The adult artist and the child both succeed in communicating something of their experience to the viewer. But here the similarity ends and for fuller understanding of children's art we must examine the difference between Van Gogh and the child.

To begin with, the nature of the experience which sets the process in motion is different in each case. With Van Gogh it was a sensual, emotional, aesthetic experience. In the case of the young child it was a personal, domestic experience. Van Gogh was concerned to express his intense feelings about the corn, the sky and so on, whereas the child was more concerned to say something about an event which happened to him and which had little aesthetic content! The drawing is much more in the nature of newspaper reporting – 'I had chicken-pox'. Aesthetics do not come into it. Communication is everything. In the case of Van Gogh aesthetic considerations, i.e. the 'dynamics' of the yellows, the quality of the paint textures, the power of the composition and the emotional charge of the subject, are paramount.

Another important difference between Van Gogh and the child is that Van Gogh's process is a one-way process. It begins with a specific experience and results in the production of a painting.

Art in the primary school is a two-way process. The child may begin with a specific experience and may produce a drawing or a painting as a result of that experience. But the process can be reversed. The teacher will provide a situation in which the child can avail himself of the opportunity to paint and as he paints he will find all sorts of new creative experiences of colour and texture, of expression, of making, and of choosing and mixing. Significant experience can be induced in the young child by the simple process of providing opportunity for artistic activity. This is purposeful use of art as an educational aid.

Van Gogh's picture is a work of fine art, a transmutation of aesthetic experience into permanent artistic form. The child uses his drawing, painting, as a pictorial language to talk to himself and about himself. By his drawing he makes plain much that is in his mind which, because of the limitation of his verbal ability, would otherwise remain unknown to us.

We are concerned throughout this book with the problems of how to use arts and crafts to help with the education of girls and boys. The child's art work provides us with a means of knowing more about him, and in doing

so makes us more able to deal with him as an individual and to develop his unique potential — this is of the utmost educational value.

The Van Gogh painting belongs to the world of fine art. The child's portrait belongs to the world of education. There is sometimes a tendency to think of these two types in the same context whereas in fact, although they share common factors, their aims, purposes and functions are poles apart.

In general and in spite of some confusion caused by extremists, the role of the artist in society is well understood and appreciated. Unhappily, in England, this is not the case with art and its function in schools of general education.

The art of children under seven years is our concern. Let us examine it more closely.

They paint what they experience.
They experience what they paint.

Fig. 104 This is a satisfactory double-sided easel. Its construction is obvious and simple. Any carpenter, amateur or professional, could make one, merely by looking at this photograph. Most education authorities supply these or something like them. Two of these (complete with pots of paint, brushes and clipped on paper), as a permanent part of the classroom set-up, make it possible for the children to paint whenever they want to, without hindrance. If organisation is poor and they are delayed just when they are anxious to start they become frustrated and are likely to give up. Painting, if it is to provide a free-flowing means of expression, *must* be easily available.

104

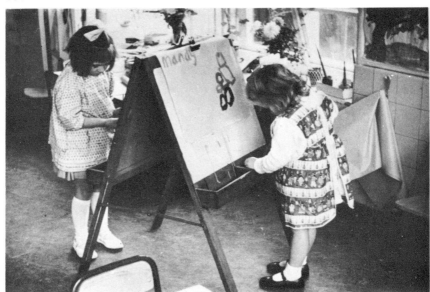

Painting as experience

They paint what they experience.
They experience what they paint.

What experiences can the young child gain from drawing and painting?
Under the present heading the term experience is intended to refer to that experience which arises out of the physical act of painting and drawing. It is clear many children have had no contact with paint before entering school. The child's first encounter with jars of fluid paint, brushes, easel, paper, is a momentous experience. Observation shows that first reactions tend to be more or less the same in most children and that development from this point follows a discernible pattern – a broad pattern with variation but nevertheless a pattern.

Let us take the example of Peter. It is his first day at school. He is confronted with paint, brush, easel, paper, for the first time. If we watch we see the usual hesitating experiments with the feel and the sound of dipping and splashing with the brush in the jar. He is confronted with a choice of colours. He makes a conscious choice of *one* colour. Then the first tentative touching of brush to paper, in which he discovers that he is master of a situation in which *he* can make spots and marks appear on the paper. This is the first step forward. His first experiments may last only a minute or two or may extend to perhaps ten minutes, but whatever the duration the discovery of the ability to make dots and marks and patches is his own personal unaided magical experience arising out of the act of using paint. The teacher, the parent, has nothing to do with it, except to provide the easel and the paint and the opportunity, and to know that such provision is necessary; to know the likely result of such provision. For the child this is creative, significant experience. This is education.

But Peter is only at the beginning. Next time he goes to the easel he may well make two new discoveries. First, if he places the loaded brush on the paper and moves it ever so slightly one way, without removing it from the paper, then the other way, there before his very eyes the spot enlarges into a patch of colour and the patch grows as he moves his brush from side to side and up and down. Second, if he touches loaded paint brush to paper and makes a wide movement of his arm, keeping the brush to the paper, he produces a line. Patch and line, painting and drawing. Out of these two experiences Peter has discovered for himself, without the aid of the teacher or the parent, the two basic principles: drawing – the line – and painting – the *area* of colour. Development from this point is usually rapid.

On the shelf of his easel are four different colours. Before he can begin to paint he must choose a colour. He must make a conscious choice and then act upon it. This is an aesthetic choice. To make such a choice is an experience which is only available from engagement with brush and paint.

Let us join him again at the moment when he discovers that he can make patches. As he enlarges his patch, there before his eyes is a growing expanse of blue. The bigger he makes it, the bluer it gets. He covers the paper all over. It is rich. It is magic.* It is his. For the moment he is possessed by it. This is

* See Piaget *Language and Thought of the Child.*

vital experience: *experience* of *blue*. Once again it is an experience which arises out of the act of using paint. This is visual exploration and discovery by the child for himself, by his own initiative, without the aid of the teacher.

The first time Peter discovers blue by painting blue. This is experience. It is an exciting experience which he may enjoy so much that he will want to repeat it.

Now imagine him entering the classroom one morning. Until now he has merely been *enjoying* painting blue. *This* morning he halts at the classroom door. He pauses. He thinks 'blue'. He goes to the shelf and he *chooses* blue, making a conscious selection of blue from the other colours. He goes to the easel − he paints blue, all over. This time there is more to it than enjoying the experience of blue. This time he is *proclaiming* blue, *celebrating* blue. In other words, from passive experience of blue he has gone over to active *expression* of blue. He makes a declaration of his feeling of being excited by blue.

This is a very important stage in the child's development. This is the beginning of the process of absorbing experience and of restating it in terms of personal expression.

It is also a moment of truth for the teacher. When the child shows himself able to absorb experience and give it out again as creative expression he shows that he has become sensitive to educational techniques. The process of transition from passive experience to active expression may be gradual or rapid but, whichever it is, the teacher will watch for it and when it happens she will make use of it, as an educational tool.

To the young child, this new-found ability of being able to make colour spread all over the paper is fascinating. Almost every child who finds himself confronted by an easel, paint, paper and brush will indulge in this process of choosing a colour, dipping the brush, spreading the colour, very often one colour, all over the paper. Often excitement over that one colour is so intense that the total covering of the paper with that one colour may be repeated many times. One teacher, a little less experienced than some of her colleagues, grew anxious about this continuing obsession with, in this case, blue. She asked for advice. 'I am *so* worried,' she said; 'he keeps painting blue all over the paper. He has painted thirty-six with blue all over. What does it mean?' 'It means', she was told, 'that he likes blue!' This teacher was, quite mistakenly, worried that the boy was 'not getting on', was 'making no *progress*'. She was afraid that it was some dreadful psychological symptom. There is always the risk that teachers may be tempted to read far too much into children's painting. It is much safer to read too little than to read too much.

To return to the 'blue' case quoted above, if the continuous repetition of painting 'blue all over' had been accompanied by lack of initiative in other ways, such as disinclination to join in other class activities or a tendency to remain solitary in the playground and so on, *then* it might be an indication that there is something amiss, but by itself it should be taken at its face value, which is an indication that he likes blue. It is as simple as that. The

case quoted above gave way not much later to the normal pattern of development which follows the initial 'patch painting' stage.

Having said this, however, it is fair to say that behaviour patterns are discernible in painting just as in any other activity. We shall be considering such cases later in the book. The sensitive teacher or parent will take account of any obvious changes. If any occur it might be a sign to check by inquiry whether there is any special cause, change at home, illness. But all facets of behaviour must be considered *together* . . . indications in the painting *alone* are not enough to form conclusions. A little psychology is a dangerous thing.

If the all-over painting persists for a really long time, even indefinitely, and ties up with lack of initiative in other ways it may indicate that the child has a need for a feeling of security. His constant resort to a known procedure may be a subconscious need to feel safe. All this together may indicate the need for some advice from the educational psychologist.

Should it arise, this situation has to do not with art but with the personality of the child. The solution will be found not in trying to interest the child in other colours, but in considering why he is reluctant to go forward, to take initiatives, why he continues with a repetitive procedure.

In this chapter we have been discussing those experiences, the excitement of creating colour and the development of means to express emotional feelings about colour, which arise out of the act of painting. 'They experience what they paint.'

The other side of the coin is 'They paint what they experience', and that belongs under the heading of communication.

Children's art as communication

Is the art of the young child fine art or non-art? It is neither. It is pictorial language.

What experiences are reflected in and by his art? How do they relate to his school work.

The child does not have to be *taught* to draw and paint. He does it spontaneously. *Why* does he do it? *Not* because he wants to 'make a drawing'. You will rarely hear a child say, 'I want to make a drawing.' He says, 'I want to draw.' What he really wants is to talk to himself in pictures. He wants to go for a walk in the park (fig. 105), or go in a boat on the sea, or join the birds, or more likely the jet airliner and fly through the air.

He wants to tell everybody about his own social experiences in the world. At his age he has no thought of making a work of art. He wants to communicate and he uses his brush and his paint, his pencil and paper and his 'visual symbol' language to do it.

Fig. 105 'Susan and Stephen in the park'. The statement is complete; to make it the child has used the simple symbols he knows: 'strip sky', 'strip earth'; 'radials' for the flowers, and primitive figures.

Fig. 106 A child writes in her diary and illustrates what she writes. Note the expressiveness of her drawings; note particularly the construction of the see-saw.

105 Age 5 years. 15×22 in. 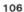106

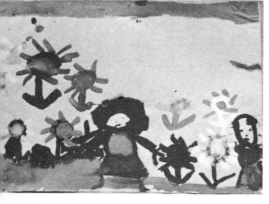

Painting as communication

The child communicates involuntarily by means of his drawing and painting. The sensitive teacher is always on the alert to see, to hear, to assess, to deduce, to evaluate.

The five-year-old is a rapidly developing human being. All day, every day, every kind of event presses in upon his consciousness. Everything – relationships with parents, with friends, with enemies, animals, situations, environment – is new. All this is 'on tap' ready to be expressed and communicated. The prolific nature of the child's personal experience of his world largely accounts for the spontaneity of his art work and the continuousness of its flow. He is never without something to express. When he has acquired the minimum techniques, he quite naturally expresses himself by drawing. Give him a ball-point pen, or a pencil, and an exercise book to use as a work book or 'diary', and see what he will produce. It will be a graphic autobiography. The child can and will very rapidly and easily, merely by using simple dots, lines, loops and patches, create a fantasy world of whatever is most important to him in his own personal experience at that time. Drawing and painting are a rapid shorthand, pictograph language of great flexibility which provides a channel of expression for the child and, probably more important, channels for the child to communicate with himself and also to communicate with his teacher, his parents, his friends.

What do we mean when we say the child communicates with himself? Go into any class of five-year-olds or, if you are a parent, place yourself near your child while he is drawing or painting. If you are a teacher and can make yourself inconspicuous, and if you can get close to a child who is painting, you will almost certainly hear him or her talking as the work proceeds, not to his neighbour but to his drawing, or to himself about his drawing. He may even impersonate the characters he is portraying in his drawing and speak for them. This is a normal fantasy situation. In this situation, the teacher, the parent, is a privileged spectator who should remain mute unless she is drawn in by the child. But she will listen and make use of the information obtained. It will be seen that these fantasy situations are in reality a part of the pattern of play practised by the young child. They are frequently intricate. Fantastic imagery is woven round the simplest smudges and blots and squiggles, all of which may be indecipherable except by their creators. The child knows exactly what everything means and will communicate with himself freely and at length about them, and with you, at that time.

When the child has completed his drawing or painting and has emerged from his fantasy, the teacher may decide to invite him to talk about what he has produced. She may be surprised to hear quite a different story from the one the child told himself while he was at work. This is not unusual and arises from those symbols which he has, so recently, put down on the paper. Each new look at the symbols starts new fantasies – some connected to the last lot, some not. He may very likely have forgotten the fantasies just past, just as we cannot recall dreams when we awake.

To persuade the child to talk about his work opens a rich field of direct

communication between him and his teacher. Conversations between teacher and child, or parent and child, are the beginning of verbalisation. Conversation entails descriptive language. If the teacher, at the child's instigation, writes on the picture the child's title for his picture, then the child is introduced to the idea of associating the appearance of written words with spoken words and both of these with the content of the painting or drawing he has produced. Very often incidents are merely included in his drawing/painting at random, or rather as his fantasy dictates; equally often the idea or content described by the title is read into the marks/symbols on the paper with little or no reference to reality.

Repetition of this procedure of invoked conversation, as a deliberate teaching technique, encourages growth of awareness of spoken and written forms and their relationship to the child's imagery, and as a consequence, to incipient development of skills in reading and writing.

Communication through and about graphic expression is a beginning of academic learning.

So far in this chapter we have been considering art as communication for the child, from the child's point of view. There is another aspect of the matter. The drawings and the paintings which the child produces provide a valuable insight into what the child is thinking and feeling and experiencing. The sensitive teacher, or parent, will take full advantage of this and will decide whether any aspect so revealed may be worth following up. What hints to take from the graphic work of the child? Young children are direct and unsubtle. They comment pictorially on any and every aspect of their lives. The teacher quickly develops a sensitivity to the implications of the children's work and will take educational advantage of the opportunities offered (fig. 107). She will strive to create a channel of understanding between herself and the child. Perhaps, too, the day is not far off when parents will be helped to a realisation of the value of such understanding to their developing relationship with their child in the home.

Teaching these young children is a continuous process of two-way communication, a continuous process of seeking to understand the child through what he is and what he does. It is opportunism on a knife edge, poised between intervention and skilled non-intervention, ready to take every chance to extend the child's experience.

So, to sum up, the teacher has available three distinct but associated means of communication which if discreetly and delicately used will help her to get to know something of what is happening within the child's mind.

1 The content of his drawing and painting.
2 The child's talking to himself while painting and drawing.
3 The child's conversation with his teacher about his art work.

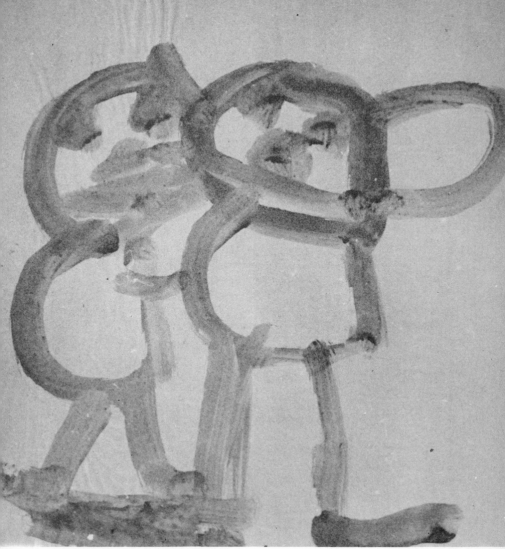

107 Age 4 years. Nursery school. 15×19 in.

Fig. 107 Carol, although a normal, happy child, was one of the few children who showed no interest in painting.

Suddenly she began to paint. She produced a series of paintings similar to the one shown in fig. 107. All of them had pairs of linked figures.

Next time her mother called at the school Carol's teacher discovered, during the course of conversation, that the father had become seriously ill and had been taken away to a sanatorium.

If a child who has hitherto shown no inclination to paint suddenly, for no apparent reason, takes up painting, this constitutes a change in behaviour. A change of behaviour in one sphere of activity may be echoed in another. Whether it is or is not, the teacher should treat such changes of behaviour as signs which may be significant and which merit discreet investigation.

Stimuli

Stimulus arises out of what the child *does*. It arises out of what he finds.
Take care that stimulation does not become dictation.

The trigger which sets the creative process in motion is some form of
experience. This is true whatever the art is – poetry, drama, painting – and
it is true whether the artist is an adult or a child. There must always be a
stimulus to activate the trigger. Stimulus, inspiration, call it what we will,
arises out of experience. The young child is so new to the world that new
experiences crowd in, through all his senses, all the time.

He experiments continually and each experiment produces more experi-
ences. He experiments with pencil, crayon, brush and paint, and it is through
his experiments with these media that he makes the first move towards
graphic expression, by scribble and patch. Any or all of these experiences
can serve to trigger off creative activity. He rarely needs to be persuaded by
teacher or parent to paint. He is full of new ideas and impressions. He puts
them all into his drawings and paintings. They come tumbling out, unbidden.
The art of the child, especially in his first year or year and a half at school, is
almost always spontaneous. Stimulation should not be necessary. The
application of inappropriate stimulus, even once, can have disastrous results.
An example of misguided stimulus is the frequently met with over-insistence
on formal pattern making. Another example of a different kind is apparent
from the following story, which provides its own moral.

Debbie was a sensitive child and from the age of three she had the use of
paint, easel and paper. She produced a series of lively expressive paintings
all of which showed her love of colour, enjoyment of paint, and her ability to
make statements about her social adventures, her hopes and fears, her
affections, her home, her brother and sister and so on. At five she went to
school. Her painting, at home, stopped abruptly. After some weeks she came
home one afternoon with an Easter card. It consisted of a folded piece of
green paper and on the front was an oval (fig. 108a) with two parallel lines
and two triangles. Each step had been drawn on the blackboard by the
teacher and each step had been copied by Debbie. Inside the legend ran,
'Happy Easter, Mummy and Daddy.'

A few days later an empty eggshell was brought home. It had a face on
one side and grass growing inside, as 'hair' (fig. 108b). The teacher cut the
eggshell. Debbie drew the face. The conversation between Debbie and her
mother was reported as follows:

Mother *(determined not to hurt Debbie's feelings)*: Oh, that's nice. Did
you do it all yourself?
Debbie: We all did one. I drew the face but the teacher made the bow a bit
better for me.

Some two or three weeks after this Debbie's mother was delighted to see
66

Fig. 108 a, b, c, d Redrawn from the originals.

her take up her drawing at home again. Debbie got as far as figure 108c and then:

Debbie: I can't draw a bow.
Mother: Oh, I think you can. Try to remember how they look.
Debbie: I can't. You do it for me.
Mother: If I did, that would be my bow. I'd like to see yours.
Debbie (*in tears*): I can't do one. You do it.
Mother: Let's tie this ribbon round a box and see how it really looks.

A piece of ribbon was tied in a bow around a box and Debbie quite happily added a bow to her drawing. The final result was as fig. 108d.

Mother (*mystified*): Why have you put part of the bow further along the ribbon?

Debbie (*in great surprise and pointing to the two lines across the egg*): Oh! is that a ribbon?

The whole episode at school and at home had the effect of confusing and frustrating the child. She had comprehended very little. She was anxious to please teacher, so she abandoned her own natural mode of expression and was attempting to carry out the sterile procedure presented by the teacher. The corrupting activity at school had robbed the child of her own spontaneity and perverted her natural genius, and it gave her nothing in return except frustration and tears and incomprehension.

The mind boggles at this story. How many of these mindless, meaningless tasks had she been called upon to perform? So this was the explanation why her own painting at home had stopped. Her young mind had become confused by what the teacher expected at school and the different sort of thing she did at home. The result: she suffered the frustration of 'not being able to do it'. And wanting to please teacher, she felt anxious. This substitution of the imposition of a task calling for the production of a stereotype end-product had robbed Debbie of her self-confidence and confused her young mind. The idea of an Easter card to take home is an understandable one, but the approach was totally antipathetic to the encouragement of creative expression. The matter could have been handled so that all requirements were met by discussion with the children; or by reading to them material relating to spring, or Easter, and then seeing whether they might be interested to make a spring picture or an Easter picture arising out of this, in their own terms, to take home for mother. I spoke earlier of the knife-edge along which the teacher must tread between intervention and non-intervention. It applies particularly in creative expression in drawing and painting. It requires so little to deflect and disillusion a child of five. One mis-spent morning is enough to cause irreparable damage.

Sometimes the most obvious stimulus of all is overlooked, both in the home and at school. The stimulus which no young child can resist is an easel with clean paper clipped on, pots of paint with a brush in each, all ready for use. The paint must be within arm's length of the paper, either on the ledge of the easel or on an adjacent table. Immediate availability is the strongest stimulus you can provide.

I recall a visit to a school where the headmistress was concerned because not very much painting was being produced. Inquiry revealed that there were no easels in any of the classrooms. The rooms were small and painting on the tables was difficult through lack of space. It was suggested that at least one double-sided easel should be put in each room and that each easel should be kept fully supplied with paint, paper, brushes and smocks. At the end of a week this ready provision was having a visible effect. At the end of a month there were bright pictures all over the walls. This resurgence was brought about merely by placing painting 'on tap', by making painting permanently and easily available.

Given this irresistible invitation the child will pounce upon it and all his teeming exciting personal social experiences will come pouring out all over the paper. Observation shows there should be little or no need for external teacher-administered stimuli to start the youngest children painting, drawing, modelling. They possess their own built-in stimuli. It seems that the mere sight of a brush and a pot of paint, a large wax crayon, a piece of clay is enough to set them working; and when the work commences, the delight of smooth, wet, bright colour or the feel of clay, acts as creative experience which in turn acts as a new stimulus, and at the stage when the child begins to create and use his own simple symbols for 'man', 'lady', 'dog', 'airplane', 'boy', 'girl', these symbols start the child's fantasy working and fantasy is probably the strongest stimulus of all.

As the child moves towards the upper grades of the school this bubbling spontaneity may modify to some extent, but it will revive instantly in response to recalled or recounted experience: a game in the playground, shopping, flowers, little brothers, birds, the told or read story. All these act as stimuli because the child identifies with them. He uses them to tell his own story, to describe his own experiences, to illustrate his own life. The sensitive teacher knows this and will devise ways of evoking appropriate stimuli by questioning, by describing, by recalling to the child activities in which he has taken part. Natural objects about the room and the nature table engage the child in speculative thought and imaginings.

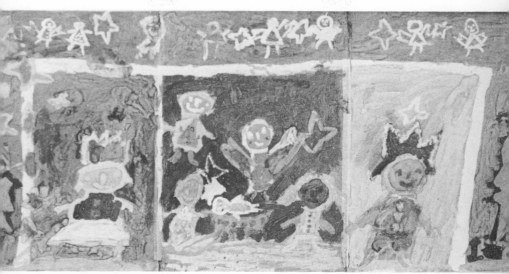

109 Age 5–6 years. 30×72 in.

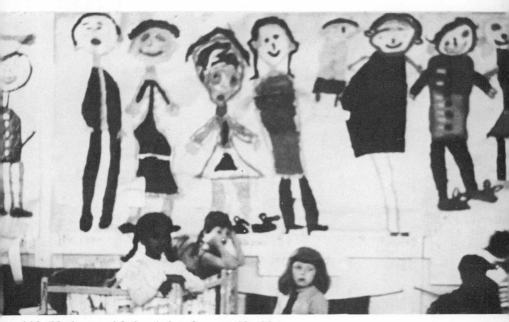

110 'Mothers and fathers'. Age 6 years. 48×96 in.

Fig. 109 The strong stimulus of Christmas and the Christmas story prompted some five or six children to produce this triptych.

Fig. 110 'Mothers and fathers' was produced as a result of 'social' stimulus after the visits of parents to the school.

E

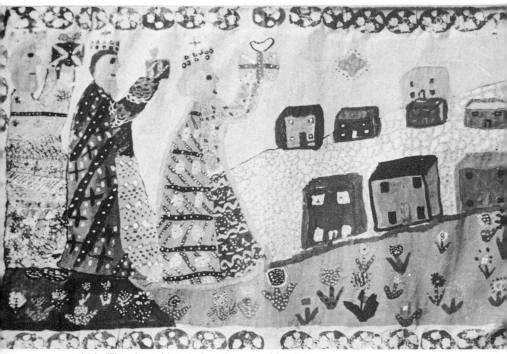

111 'The three kings'. Age 6 years. 22 × 34 in.

Fig. 111 'The three kings', another picture stemming from Christmas and produced by older children who were encouraged to enrich their picture by printing with potato blocks. Teacher administered stimulus.

Visual stimulus may be of great value to teacher and child in the upper grades of primary school. It is at seven years that the child sometimes shows dissatisfaction with his drawing and painting. With the lessening of his spontaneity the child's self-confidence tends to diminish. At this stage the teacher would do well to be ready with objective subject matter. Children have a strong sense of curiosity. This can be translated into visual curiosity by surrounding them with beautiful natural objects; the objects then become the subject of visual exploration. Visual exploration makes for discovery and visual experience. Again, children react warmly to musical instruments. A child exploring the strings, the keys, the pistons, the tubes, while holding a musical instrument, makes a visually attractive link between figure and instrument. This association of instrument with figure can lead on to dressing-up and so on. The effect on the class of a child dressed-up is to set them all in a state of excitement, the very excitement out of which springs creative expression of all kinds – writing, painting, drawing. This is my definition of visual stimulus. The child, of course, should not be expected to *copy* what he sees – he would find it impossible anyway. The aim of visual stimulus, allied to the leading-question routine, is to evoke a climate of creative fervour.

A group of slightly older children in an urban school were studying India. One group decided to paint a snake charmer. The teacher dressed up a little boy who was in the class. She tied a red scarf round his head to make a turban; a red jewel glistened in front of the turban. He was wrapped in a figured red silk dressing gown, he sat on a red patterned carpet, against a red draped curtain. He played on a red tin whistle and a red snake was lifted by rod and line out of a red jar as he piped a tune. There was a fever of excitement and the children fell to painting with gusto. Half an hour later a little voice said, 'Can I move now, my legs have gone to sleep?' The stimulus had worked so well and had started everybody painting so excitedly that 'the model' had been forgotten (he soon recovered!).

The very young child is not wholly of this world, but gradually as he grows older he becomes more and more part of it. Growing visual awareness is part of becoming more and more identified with one's environment. It is not surprising then that visual stimulus becomes more necessary and more significant to the child as he moves ahead in the elementary school. It seems to me there is a sort of calendar of growing awareness of visual stimulus.

The child in the lower class of the school notices things, and *may* sometimes express some of his visual impressions. The child two years older may very well 'see' and then use his visual impressions as a 'starter' for his various forms of expression (for example, the snake charmer described above). At eight years of age the pupil may 'register' and then directly use the model and his visual impressions *'observing as he proceeds'* with his expression. The ten-year-old is likely to become involved and absorbed with the visual aspects of his environment and he may learn to impose his will upon the visual material he uses.

Visual stimulus is always present but is used to different degrees by girls and boys at their different stages of development.

Visual stimulus is a 'way in'. It provides continuity between lower and upper levels in the school system.

Fantasy

Every parent and every teacher has seen a young child of, say, five years engaged in imaginative activity. A round box lid becomes the steering wheel of a motor car. A block of wood becomes the motor car itself and is pushed along with accompanying sound effects. A cardboard box, if big enough to sit in, becomes a house, or a ship (fig. 112).

Imagination is vivid at this age. The slightest of 'properties' is enough to sustain the most elaborate dramas; material deficiencies are compensated for by the creative imagination of the child. The cardboard-box ship becomes more real than a real ship and, what is more important for understanding the child, his involvement with the cardboard ship is sometimes more real than his involvement with the actual world.

Children will often make categorical statements which do not fit the facts of the adult world, but before we accuse the child of untruthfulness we must consider what imaginative activities may have led him to make his statements. The child in fact lives partly in a world of make-believe and imagination, and partly in the real world. When imagination has the upper hand he is in a fantasy world. The young child appears to have the ability to stand back and see himself in this fantasy world. He dreams himself into all sorts of situations. Events in the child's real life are turned by him into fantasy. His

Fig. 112 The children have found a cardboard box, some string and a stick. A ship is in course of construction. The sides of the ship are decorated with paint.

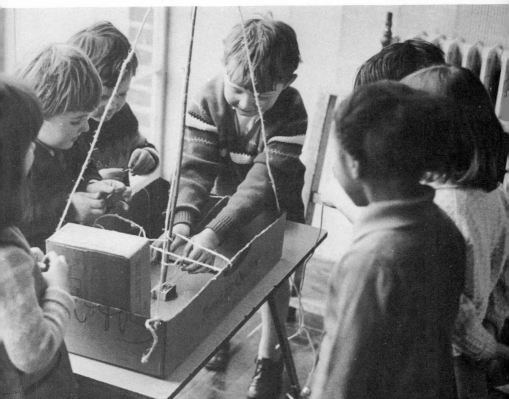

mother, father, brothers, sisters, friends, enemies, all feed his fantasy and people his dreams. We have already discussed how in drawing and painting there comes the day when the child produces and finds within his scribble and/or patches a random oval shape; how in this primitive symbol he sees a human head/body. He finds this in the marks he has put down on the paper. That which he himself has put on his paper suggests to his mind an image, his mother possibly. There is a 'feed-back' from his own drawn image, through his eye to his imagination, which then becomes involved with this rapport between him and his work in progress on the paper. Through the medium of his imagination the child communicates, in a state of fantasy, with himself. The developing fantasy reacts upon the developing image on the paper; this the child adds to or modifies with brush, or pencil, or fingers. His picture or drawing grows and changes and in turn intensifies or modifies the self-communication of the child. It is a chain-reaction, self-generative, linking with everything in the child's daily life. His painting opens windows and doors for him to reach out and for us to look in.

Gradually the child learns, consciously, to produce and then to use and project the symbols which he began by finding in his own work.

The simplest rectangle becomes the most palatial block of flats. Mother is resolved into an oval. The cryptic drawing evokes fantasy and in its turn fantasy induces simple symbol drawing.

Let us now think back for a moment to Peter and his 'blue all over' painting (page 59). Remember how he began by painting blue on his paper and enjoying what he had done, by discovering blue and being excited by the discovery. Remember how from *experiencing* blue he then moved into the more positive stage of using his new powers to '*express*' blue.

There is a parallel between Peter's discovery of blue and the way in which a child discovers the 'large head' symbol in his scribblings. He begins by enjoying the physical sensation of scribbling, then comes visual awareness of the mazy lacy patterns he is creating, then comes the finding of the symbol. At that point he will seize upon this symbol and will seek to repeat it, and as his manipulative skill and his powers of co-ordination increase, he will be more and more successful in repeating it. From this moment his work will be much less art and much more language, because as soon as the symbols which he can make, manipulate and arrange reach the stage where he can identify with them, they become a major part of his fantasy imaginings and play.

His drawings provide the child with a quick simple outlet for stating his dreams, ideas and experiences in his world of school and home, teacher, family, friends and all that goes to make up his young life. The content of his work is all-important to him, to his teacher and to his parents.

Don't bother about the handwriting; read what he has to say. Remember what he is about. The important thing is that he should express his fantasy. The content is more important than the way in which he expresses it. To criticise the way he draws – how he relates, or fails to relate, one item to another in his picture – or to criticise his indifference to proportion or scale

113 Age 5¾ years. 15×20 in.

114 'Signals'. Age 4 years.
Play group. 15×22 in.

Fig. 113 The child hovers between the world of fantasy and of reality. If something is important to him at the time, he paints it big. In the fantasy world, who knows how big, or how small, things are?

Fig. 114 'Signals.' The red and green marks on the paper are virtually unintelligible, but while he was painting the marks the child's private, personal spoken running commentary was lengthy and highly detailed. This was noted down by his mother and filled two or three pages. It explained the child's imaginings about, and knowledge of, the rules and regulations of traffic control and of railway organisation. All of it was closely related to the bits of red and green paint he had placed on the paper. The other side of the coin is the child's tendency to assign emotional characteristics to graphic forms.

would be to miss the educational point, which is that he should express what he has to say in his own way and find vital experience in doing so.

One aspect of the child's art fantasy is a continual flow of verbal commentary which may or may not have any direct bearing on, or relationship to, what he draws or paints on the paper.

This spoken commentary is of great significance and the watchful teacher will listen and deduce, will encourage it as much as possible and will make use of it to help to build up a whole picture of the background of the child.

Look at figure 115. It is taken from a twenty-four page book which carried on the cover the title 'My House'. Each page was a child's drawing of his or her own house. The school where the book was produced was in a slum part of London in an area of small dingy Victorian houses, the only exception being one new tall apartment block. Twenty-three of the children's drawings representing 'My House' were typically a square with a window at each corner, a tree each side of the house. All were almost identical. The only exception was the drawing illustrated opposite. A shy little girl admitted to authorship of this exception. Yet when questioned as to whether she lived in the beautiful new block she said that she did not, and when she was asked, 'But, if you *don't* live there, why did you draw it for your home?' she replied, 'I *saw* it.'

It is easy to imagine this small child walking to school along the narrow street lined with small low houses. She looks at the glittering tower of white concrete, sparkling glass and shining metal. To her it is a remote mysterious fairyland. By comparison with her own house it is desirable. For the young child to desire is to have; to imagine is to be. To imagine she lives in the apartment block is really to live there. The dividing line between real and unreal is indefinable. She saw it – that was enough to justify her drawing of this impressive building.

To the child everything is real, no matter whether it is factual or imaginary. For the teacher and parent one fact of great importance emerges out of this situation and that is the reality of the child's growth and development through fantasy.

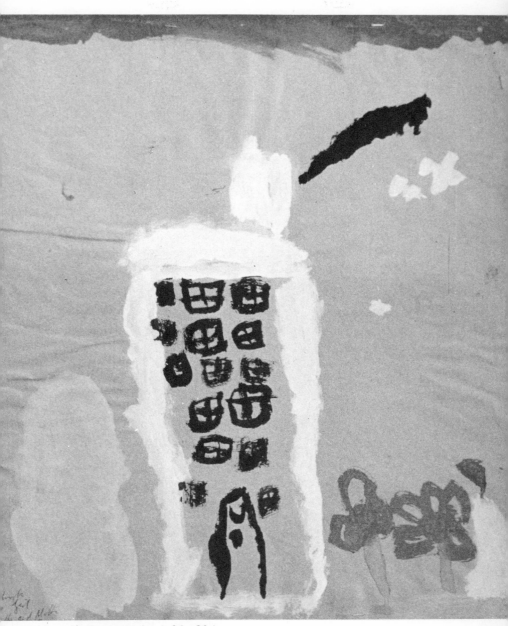

115 Age 4½. Nursery school. 24×20 in.

To the child everything is real and yet, in contrast to this, the child's interest in the drawing or painting he produces is often quite ephemeral. Children will often display no interest in what they produce once it is completed. The illustration in figure 117 is a case in point. 'It's not a bad elephant, is it,' said Stephen's teacher, 'for a boy of four. Stephen, come and tell the gentleman about your painting.' Stephen was very much occupied with what he was doing with the water, and needed more coaxing before he would break away. He then stumped across the room to where his elephant was displayed on the wall. He stood before it and bluntly said, 'A n'orse!' Then he stumped back to what he was doing before he was interrupted.

This loss of interest in work once it is completed is normal and reinforces the theory that drawing and painting belong to a game of fantasy, only of interest to the child while it is being played. The work produced is in fact merely a by-product. This is certainly true in the first stages.

If we train ourselves to observe and understand the drawing and painting of young children, if we equip ourselves to compare what they produce with those patterns of development which we have examined earlier, and if we look at these in the light of our experience of the way children think and react, we shall be able to evaluate and assess a significant aspect of the development of the child.

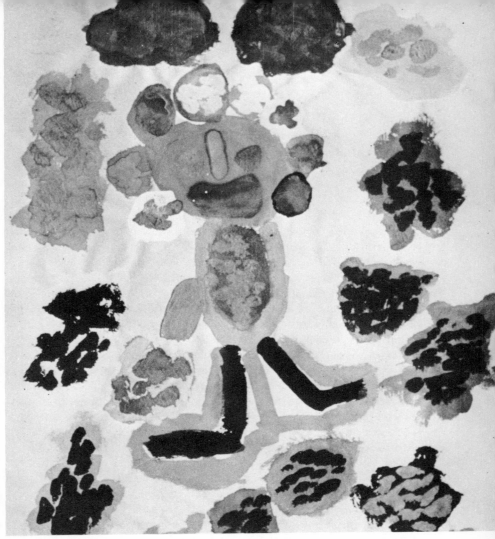

116 'A little girl covered with stars' was the title given by the child to this painting. Age 5 years. 30×22 in.

117 'An elephant'. Age 4¼ years. Nursery school. 15×22 in.

Assessment

The logic of the young child

Father, to his young daughter aged four: 'What are you drawing, Susy?'
Susy: 'I don't know, I haven't finished it yet.'

Think back for a moment to the 'My House' drawing by the young London schoolgirl (fig. 115). How should we assess it? Were the mental processes which caused her to produce her picture logical or illogical? How appropriate would it be to say, 'Naughty girl, who's telling fibs? You know you don't live in that tall building. Go back to your seat and do *your* house'. Or should this young artist be assessed as a sensitive, imaginative child with rather more than average powers of observation for her age, originality of mind, more co-ordination with brush and paint than a good many of her contemporaries, good powers of organisation and a sense of poetry.

If the latter, then this adds up to an impressive list; a list which represents the sort of assessment one might expect to make of an academic exercise in an academic subject. This is a clear example of the child using art, i.e. drawing with paint and brush, as a visual language. This young girl was using her brush and paint in a similar way to the senior pupil who uses his English prose to produce a passage of imaginative writing.

Very young children have a logic which is entirely their own and which the teacher will learn to recognise, understand and accept. Some manifestations of this logic are well known. Perhaps the most common is the strip of sky painted along the top of the paper (see fig. 118) and a corresponding strip of land along the bottom. To adult eyes this seems preposterous. To the child of five or six the sky *is* up above, the ground *is* down below and in the middle there is nothing. You can wave your arms about and feel there is nothing. This is logical. It is inappropriate to persuade the child to extend the strip of blue downwards. He will do it himself, when he is ready.

The very young child paints what he knows, not what he sees.

Four children painted their Christmas party (fig. 167). The best Christmas tree is the biggest Christmas tree. This one is so big that there is no room to put the fairy on the top. To these children a Christmas tree without a fairy was unthinkable, so they put the fairy at the side. After all, fairies can fly; so this is logical.

Two children were painting side by side on a long paper which stretched from side to side of their table. They were painting their family going for a walk. 'I'll do the sun,' said one. 'No, I'll do the sun.' 'We'll both do the sun!' and so two suns appeared, one each end of the paper. The painting proceeded and in the centre of the paper was the tray containing four jars of paint and two jars of water. When the painting was completed the children lifted the tray away and revealed a square patch of unpainted paper underneath. This caused only momentary surprise and the square was painted over as though nothing had happened.

Another feature common to young children's work is the absence of proportion and of comparative proportion. As an instance of the former,

80

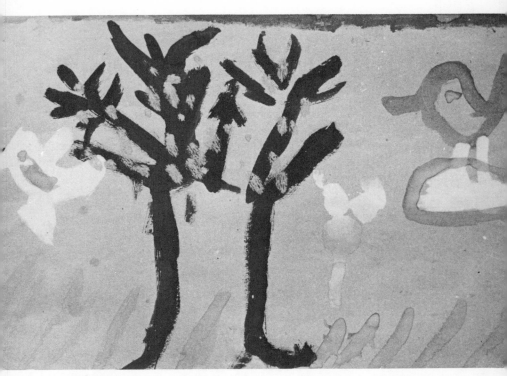

118 This illustrates a strip sky, typical of the work of the child at this stage of development. Age 5 years. 15×22 in.

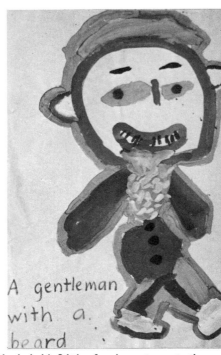

A gentleman
with a.
beard

119 'Lady and tree'. Is the tree small or the lady big? It is of no importance to the child. Age 6¾ years. 30×22 in.

120 A bearded gentleman visited the school. One of the children painted his portrait and presented it to him! Age 6 years. 30×22 in.

Fig. 121 The bride is given much more prominence than the bridegroom, who tends to be a slightly dissociated and less significant figure. This is a drawing in charcoal. Drawing done at home.

121 Age 6 years. Drawing done at home. 12×15 in.

heads are nearly always large and not 'in proportion' (fig. 120). As an example of the latter a woman may be represented the same size as a tree (fig. 119). Other not infrequent manifestations of this can be seen when a little girl depicts herself as the bride at a wedding. The bride is nearly always shown large whereas the groom is shown as an insignificant little male figure (fig. 121). Proportion is frequently equated with the significance, or intensity, of experience. An example of this is the little girl who had severe ear-ache; afterwards she painted a 'big head' figure with a very large ear. I recall a parallel in the classroom when a child who cut her finger drew a figure with an outsize finger and bandage.

As C. E. M. Joad wrote, 'Compared with a mouse a rabbit is big. Compared with an elephant a rabbit is small. So, is a rabbit big or small?' If a child's thoughts about a subject are big she draws big.

A child has his own sense of orientation. Figures standing on one side of the lawn lean one way, and those on the other side lean the other way (fig. 122).

122 The fence, the flower bed and two lines of children *surround* the man who is sweeping up the leaves. Age 6 years. 20×30 in.

Progress and development

What should we expect from the young child? How far does his art indicate his general progress?

Education is a continuous, cumulative and changing process. Progress and development must be assessed and evaluated.

We cannot advance very far in assessing general progress and development through art until we have learnt to read and understand children's graphic work, and it is important at this point to make a distinction between, on the one hand, the child's painting and drawing as art, and on the other as expression and communication enabling the teacher to understand and help the child. It is vital for the teacher to be aware of this distinction. It is far more important that the teacher should not place too much emphasis upon the child's work as art – on trying to assess whether it is good as art – or worry about her own capacity to judge art in general, and children's art in particular, as fine art. The second of the two alternatives is the one which concerns her most, i.e. the use of school art as a means to education in the full sense. In other words, we are not judging the child's work as *art*. We are not so much looking at the finished product, the drawing, the painting, the model, as evaluating the *implications* for his general progress of what the child has produced. For instance, as we have already seen, a child may change from drawing to covering sheet after sheet of paper with single bright colours, or patches of different colours within the same sheet. The sheets may contain nothing more than haphazard blobs of colour but, in an infant painter, the *implication* of this may be that he has suddenly become aware of colour, or perhaps has suddenly *returned* to colour.

Teachers sometimes say, 'I don't understand art' or 'I am no good at art'. The reasons for this are not difficult to see. A great many teachers in different countries are recruited from schools where the pupils 'drop' art at the end of the second and, sometimes, even at the end of the first year. Training in art in some colleges of education, except for the relatively small percentage of students who take art as a 'main' subject, may occupy a very small part of the course. There are still many teachers who had *no* training in art at college, especially those of the older generation. Happily today the position is improving but there is a long leeway to make up yet.

In Great Britain all primary-school teachers are called upon to include drawing and painting in their teaching, even those who 'dropped' art at the age of eleven or twelve, and who have had no contact, of any kind, with it since. It is not surprising that a large number feel inadequately equipped to deal with the subject. Those who try to broaden their own artistic outlook by visiting exhibitions in public and private galleries are bewildered rather than helped by the incomprehensibleness of much that they see, and by the apparent contradictions in what they see.

This adds up, in teachers' minds, to a lack of confidence in their own ability to deal with art as a subject and to assess the art work which young

children produce. Yet this lack of confidence need not be. Ability to draw, paint, sculpt and the rest is not in itself an indication of ability in art. In teaching five- to seven-year-olds it is a tragic and wholly unjustifiable mis-understanding to imagine that practical ability to draw, to paint, to work in some graphic or three-dimensional medium and knowledge of the history of art are essential before the teacher can organise art as an activity in the school, or can understand the drawings and painting and craft work of the young child.

The teacher who has passed through secondary school and teachers' college without any help towards visual appreciation and the appreciation of art lacks that much of richness in her life, but this lack does not impair her ability to learn the art language of the young child. Any teacher can do this.

The teacher who has passed through secondary school and teachers' college without ever having known the enriching experience of creative activity in at least one of the artistic subjects – painting, graphics, design, pottery, modelling, sculpture – is to that extent a deprived person, but that does not mean that she cannot watch and attune to the children's activity, that she cannot develop foresight and the ability to anticipate their needs as to materials and equipment for painting, drawing, modelling.

Insufficient training and experience in art will mean that the teacher will to some extent lack visual sensitivity and awareness, but this does not mean that she is insensitive to the child and his development in drawing and paint-ing at his own level. This misconception must be corrected, once and for all. Although experience in and through art is of the utmost value to the person-ality of the teacher, lack of it will not prevent her from being highly successful in the use of drawing and painting and craft in the classroom. In fact there may even be something to say for this lack. Too little confidence may be less dangerous than misguided over-confidence. There is no greater danger to children's artistic expression than the influence of the enthusiastic teacher who goes out every weekend making pen and ink sketches of Elizabethan houses and who then returns to school to teach the children how to do the same, or to draw them for the children to copy, or 'fill in'. The saddest sight to see in a primary (elementary) school is the large landscape picture drawn by the teacher, to which the children have stuck cotton-wool clouds and template daffodils and gambolling Walt Disney lambs; and there are other variations of this. This is not creative activity. It is meaningless busy work which may have dangerous side effects. But this is not to say that it is a bad thing for a teacher to be a sensitive amateur artist.

To be a sensitive practising artist and a sensitive practitioner of young children's education is the ideal combination for education through art in the primary school; but if a choice has to be made between a teacher who is a skilled painter and another who is a sensitive person with an understanding of young children's education, the educationalist is the one most likely to benefit the children.

So teachers, take heart. If you understand young children and are familiar with the appropriate techniques of their education, use these to judge the

F

123 Age 4 years. Nursery school. 15 × 22 in.

124 Age 4 years. Nursery school. 15 × 22 in.

125 Age 4 years. Nursery school. 15 × 22 in.

126 Age 4 years. Nursery school. 15 × 22 in.

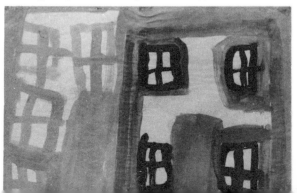

children's art work. Don't forget many local authorities run art and craft courses. Why not enrol for the next one?

If we accept that art for the child is a language, a means of expression and communication, then, logically, there can be only *one* way of assessment, and that is, to assess the content of the work. We must, therefore, deviate for a moment or two to consider the sort of content we are likely to encounter in children's art work. It falls under two general headings, explicit and implicit. Let us look at one or two simple examples.

Let us return to Peter's 'blue-all-over' painting (fig. 124). The 'explicit' content is an area of blue, nothing more; it has no symbolic meaning; it represents no event, no scene, no person, no object. If we take 'explicit' to mean that the content explains something, then this 'blue-all-over' painting explains very little.

What of the 'implicit' content. We remember what happened in Peter's mind while he produced this painting. How he found blue, how he loved blue, how he was excited by blue, how he expressed and celebrated blue, and how by so doing he communicated something of his excitement to us and his teacher. In other words the implicit content is very much greater than appears on the paper, than meets the eye – much greater than the explicit content – and, what is more, it was of great significance to Peter, and to know what Peter is experiencing is of great significance to his teacher and to his parents.

Now let us look at another example; this is an uncomplicated, easily readable piece of work. It explains everything – it is explicit. It implies no more than it explains (figs 127 and 128).

Experience of constantly looking at children's graphic work will soon enable teachers to recognise the typical modes of expression, and to evaluate the implications of its content; progress in handling colour (for instance, from mess to clarity); development of texture (i.e. enriching of the surface of the paint); invention of new symbols; wider observation of life and expression of it; evidence of enjoyment; development of initiatives.

In assessing children's work we must constantly remind ourselves and constantly search for re-affirmation of the fact that the young child has his own natural personal manner of expression and that this is a measure and indication to help in determining his developmental age. We must always be on our guard against imposing adult standards and criteria upon him. 'The arms are too short' has no place in the classroom. Such criticisms should never enter the teacher's mind, much less cross her lips.

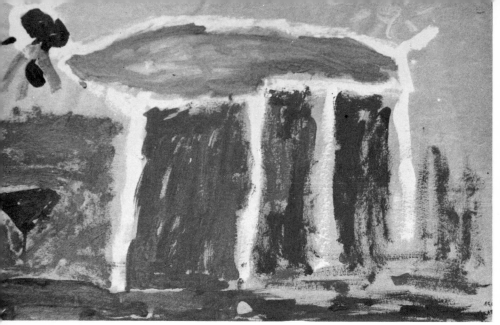

127 Age 5 years. 15×22 in.

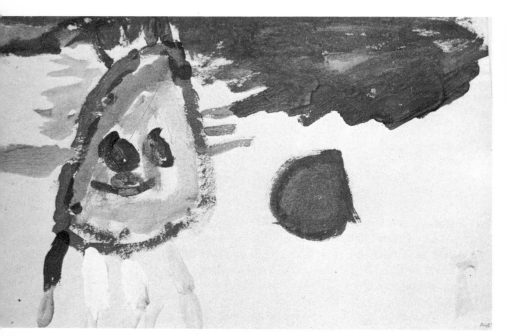

128 Age 5 years. 15×22 in.

Figs 127 and 128 These two drawings were made one after the other by an intelligent five-year-old girl. It is unusual for so young a child to treat a subject in both profile and full-face in this way. Both drawings took about four minutes. The titles she gave to her work were: 'Pussy from the side' and 'Pussy from the front'.

129 Age 3¼ years. Nursery school.
15×11 in.

130 Age 3¼ years. Nursery school.
15×11 in.

The above two pieces of work (figs. 129 and 130) in felt-tipped pen and crayon were both produced by the same small boy within a few days. Before reading any further, look at them and see whether you can decide:

1 Which one was produced first.
2 What is the difference between them.
3 What it was that brought that difference about.
4 If one of them is a development from the other, what is that development.
5 Which is the better 'work of art'.
6 What the child got out of doing these two pieces of work.

Now compare your views with those on the next page.

1 The 'disconnected' (fig. 129) one 'A' was produced first.
2 The difference between them is that the second one is more 'organised'.
3 It is more difficult to find the answer to the third question. It lies somewhere in the area of more acute perception allied to more responsive muscular control and co-ordination, and in development of the sense of pattern which seems to be innate in very young children.
4 The development is partly physical (optical/muscular), partly mental (co-ordination between eye, hand and brain).
5 There is no answer to this question, only opinion and taste in the matter. Critics would no doubt disagree, but in my view the Kandinsky and the Mondrian (figs 131 and 132) are close parallels in content; and in this case too it is not possible to say which is the better work of art.
6 The pleasure of making the dramatic black line and of watching the pattern grow.

Note: Only one of these six questions calls for the exercise of artistic judgement and to this one question there is no answer.

The other five questions can be answered by any sensitive person and these five general questions are the ones which are relevant in the education context. No special training or ability in art is called for to make this kind of assessment. Study of the children's work plus knowledge of the individual child is what is needed to evaluate their creative work and its implications of development.

Some criteria

The drawing and painting of young children frequently achieve a quality which can be accurately described as art, but it is different from the art of a Bonnard, a Rembrandt, a Picasso, T. S. Eliot, Dylan Thomas, Henry Moore. The difference consists in the fact that all small children, in every part of the world, find the same or very similar symbols to express themselves and these symbols soon become recognisable to teachers and parents because of the frequency of their use.* The professional artist for his part frequently uses forms of visual expression which are new and strange and which confound and confuse not only the ordinary viewer but also the professional critics.

A characteristic feature which we must take into account when assessing child art, and I make no apology for mentioning it yet again, is that the young child uses his drawing and painting as a form of language, for communication. Because this language and communication provide a direct and positive method and discipline for developing, educating and training the child, I submit that the soundest criterion for 'good' child art is that it should be seen to serve an educational purpose.

* Rhoda Kellogg, *What Children Scribble and Why.*

131 'Battle' by Wassily Kandinsky. 1910. Oil on canvas. $37\frac{1}{4}\times51\frac{1}{4}$ in. Tate Gallery, London.

132 'Composition with red, yellow and blue' by Piet Mondrian. 1939–42. Oil on canvas. $28\frac{5}{8}\times27\frac{1}{4}$ in. Tate Gallery, London. Compare this with fig. 131 and both of these with figs 129 and 130. Is there any affinity?

If we accept the above submission, then there are many questions which we must ask ourselves when we set out to assess a piece of art work by a young child; for example:

1 How did painting *this* picture *help* this child?
2 What good accrued to the child while he was engaged in this activity?
3 Did he enjoy doing it?
4 Did the making of this piece of work provide him with any new or valuable experience or involve him in any new activity?
5 If so, did this experience add anything to the child's developing personality?
6 Does the work provide evidence of any improvement in muscular co-ordination, in tidiness, in cleanliness, etc.?
7 Is there any evidence of development of the power to concentrate, to discriminate, to choose?
8 Can we say that the painting of this picture helped the child to see, to feel, to grow, to imagine, to develop, if ever so little? If we *can*, then the art work is *good*.
9 Did this work provide the child with a means of externalising personal emotions and experience, such as stresses and pressures, i.e. did it help him to 'get it out of his system'?
10 If it did, was it a good thing?
11 Did difficulties arise? If so, how did he meet them?
12 What new initiatives did he take?
13 Does he display a leaning towards pattern, towards colour?
14 How do any evident leanings tie in with what he does in other aspects of his work?
15 Is he positive or tentative in his work?

To the teacher

It must be a matter for concern that many teachers of young children are worried by what they mistakenly think to be their inadequacy to deal with art in the classroom; by what they call their lack of practical ability in, and knowledge of, art. I hope that discussion of this in the previous chapter on progress and development has helped to allay these anxieties.

It cannot be too strongly or too often stated that art and craft generally and drawing and painting particularly are for the small child a language first and only incidentally an art form, though, as has been said, the mechanics of the child's visual language are very similar to those of the adult artist. Indeed the child's art activities frequently produce works of art of inescapable charm, poetic sensitivity, dramatic intensity. To be surrounded by such work is one of the rewards of this kind of teaching. All the same this quality in child art produces anomalies and difficulties. Amongst these is the cult of the child artist and the false values arising out of exhibitions of child art. The teacher will not allow herself to be deflected from the main purpose of the schoolchild's art activity, which is educational. She will hold fast to the knowledge that she is equipped to judge the educational worth of her children's work if only she will apply educational criteria to it. This is not to say that her judgement will not be more flexible if she is sensitive to the aesthetic qualities of painting, drawing and the rest, but she is equipped to judge without these.

Most of the above comments apply equally to craft work, though many teachers seem less tentative in their approach to craft in the classroom. In schools where the 'integrated day' and 'integrated teaching' are the rule, craft activity plays a major part in welding the curriculum together. A closer look will be taken at 'integrated teaching' under the section on organisation (page 106) and at the subtle differences in the function of crafts as distinct from drawing and painting in the classroom; this is discussed under the heading of crafts (page 129).

The soundest advice which can be given to the teacher is that she should examine as much children's art work as she can and train herself to apply the criteria already discussed and to continue this as an exercise in judgement until she has the ability to 'read' the children's work and to recognise the significant characteristics. This kind of examination can be salutary and may provide diagnoses which extend beyond the child, especially in the seven-year-old age group.

Gradually the teacher will learn to adjust her relationship with the child so as to meet his needs as at that time. Teaching young children is a kind of opportunism, of watching the child and seeing the moment when he is ready. She will develop and learn to trust her own sensitivity of perception and intuition. She will learn to divine the narrow path to tread, the knife-edge division between the child's fantasy and reality, between his experiences and his expression of those experiences, to recognise where they overlap and where they divide as is made apparent in his art work.

Every good teacher-training course includes in its curriculum opportunity to study and assess children's art and craft work. This is an area of education

93

where research into teacher training and teaching methods would yield rich dividends.

The Plowden Committee reviewed primary education in Britain and published its report in 1967. The short section on art showed no new thinking and the recommendations did not include suggestions for future policy. It would have done well to take heed of the advice offered by the Society for Education through Art on the need for research into the function of art in the primary schools, and the suggestions made by the same society for helping teachers who have to teach art to seven- to eleven-year-olds. This enquiry might have initiated a helpful step forward here. What a pity the opportunity was missed.

How much and how far to teach

This question is frequently asked by teachers of young children. Part of the answer to this is to be found under the earlier heading of creative activity. But in its acutest form and in our context the question means variants upon: 'When the child is painting or drawing should I help him?' 'Should I show him how many fingers there are on a hand?' 'Should I say, "The arms are too short"?' The answer is that in general the teacher should not intrude when the child is working happily and spontaneously. She should limit her help to answering questions; these are likely to be rare in the early stages and somewhat more frequent as the child reaches the age of seven. The teacher will be familiar with the technique of dealing with questions in such a way as to gain the maximum value from them, of, for instance, turning the child's question round and aiming it back at him and so evoking from the child responses which are the answer to his own original question. If the teacher gives help unasked she may in fact be intruding in a harmful way.

If, for instance, she approaches a child while he is painting a figure and says 'The arms are too short' the child will readily make the alteration. The length of the arms is completely unimportant to the child and to the expression of his fantasy. Look at figure 133; it is not clear whether the light-toned shapes depending from the chin of the figure are hands or arms. The total figure reads logically in spite of its lack of proportion. There is no doubt that is satisfies the child; to him this *is* Samuel's mother. The length of the arms is immaterial: adult standards and proportion are not within the child's comprehension, they are not necessary to him for his means of expression. Therefore to say 'The arms are too short' does not really make sense when what he is interested in doing is to make a picture of 'Samuel's mother'. The child is making a statement about a personality remembered from a religious education or Sunday school lesson. As was said above, the child will readily alter the length of the arms to please the teacher. He will in fact do *anything* to 'please teacher'. What is so destructive is that once the child is made, by misguided help, to feel that his work is not what teacher wants he will reject his own spontaneous expressive way of drawing or painting and will only work in a manner which he knows teacher approves. His own spontaneity will be gone and he becomes dependent upon direction by the adult. He will

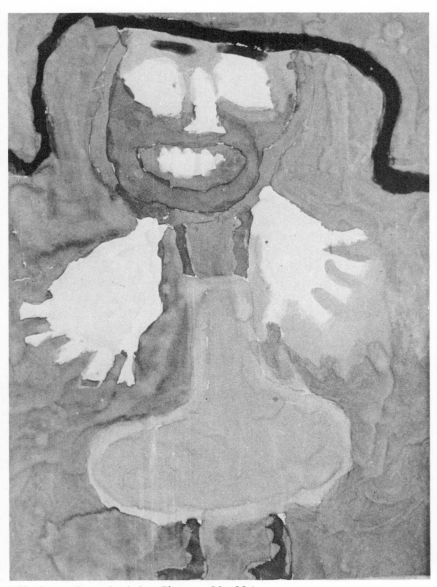

133 'Samuel's mother'. Age $5\frac{1}{2}$ years. 30×22 in.

be less inclined to take the initiative himself. It is at this point that the parent can unwittingly cause so much damage. Parents everywhere, not all parents, but very many, do so much that is harmful to the 'artistic' development of their children. For example by:

Drawing for the child.
Presenting painting books to the child.
Presenting him with painting-by-numbers outfits.
Providing poorly illustrated 'picture books'.
Buying inefficient paint boxes – those with fifty or so colours in very small pats which are so hard they yield no paint however vigorously they are scrubbed and which become detached and lost.

The first three of these are by far the most serious because they inculcate in the child false values. Because mother or father draws a ship or a man in a certain way the child thinks that is the 'right' way. He seeks to imitate, he fails and is frustrated. So he asks his parent to draw it again. The child is dissatisfied with his own drawing/painting because it is not like his parent's, or the cliché in the painting book, or the 'bunnies' in the picture book. Any influence which runs counter to the child's own uniquely personal development, or tends to wean him away from his own natural mode of expression, or shakes his confidence in his own performance with paint and drawing, should be avoided, at all costs.

As teachers we bear a heavy responsibility.

In the early days of school life, the child lives half in and half out of a world of fantasy. When he is painting or drawing or making things or indulging in imaginative activity he is almost always in a state of fantasy. When he *is*, he has no need of teaching, or help. In fact to interfere with him then would be an intrusion, which would be uneducational. By the time he is six years old this situation will begin to change. By seven it will have changed and by this time he will almost certainly need help. We must then assess the whole state of the child, his rate and stage of progress as we read it from all he is and does. We must then adjust our teaching to meet his needs at that point in his development.

The following questions have all been asked by teachers:

1 Should I draw for the child?
 No!
2 Why not?

Because if you do, the child will look at what you draw for him and will say to himself, 'That must be right because teacher drew it. That's how she would like me to do it. I must try to do it like *she* does.' In the child's eyes the teacher is a goddess who can do no wrong, but the moment the child seeks to please his teacher by what he draws, by taking the sophisticated style of the teacher as his model, then never again will he draw spontaneously, out of his own experience and in his own terms. His innocent vision will be lost and the damage may well be irreparable. What is worse, the

child will suffer endless frustration because he will never be able to match the advanced technique of his teacher; more and more he will resort to asking her for help. He may end up by being entirely dependent upon her and a nuisance to himself and to the rest of the class.

3 Should I try to 'get him on faster' by making suggestions?

This question was asked by a teacher in relation to a picture by a five-year-old with the typical blue strip sky along the top of the paper (fig. 77). The answer to this is that verbal suggestions have much the same effect as when the teacher draws for the child. There is a danger of inculcating false values, or at least inappropriate forms of expression, 'Teacher said I ought to paint the sky all over; she's nice, I like her, so I'll do it.' The child will certainly do as he is asked but his picture will not be as it *would* have been if he had been left alone. It will not therefore be a genuine form of child expression. It is a mistake to think that if the child is persuaded to paint the sky all over he has thereby been 'advanced in learning', that this means he is 'getting on faster'. It would be as inappropriate to train an illiterate Englishman to repeat poetry in Japanese. He might master the sound of the words but he wouldn't understand what he was saying and he would be no more 'cultured' after the exercise than before it. The answer to this question is, 'No!'

4 Should I stop them if I see them copying one another?

There is no simple answer to this question, as may be seen from the two pairs of pictures illustrated in figs 134, 135, 136 and 137. Obviously if one child becomes dependent upon another this is bad, and the only satisfactory method of stopping the practice may be judicious separation. But not all copying *is* bad, as can be seen in the second of the pairs of paintings, figs 136, 137: (*a*) began to paint; (*b*) began to copy; (*a*) was a very slow worker; (*b*) lost patience and raced on ahead. The result was two quite individual paintings. No harm done. In fact some positive good if (*b*) was a very timid child, afraid to start on his own.

5 Are painting books good or bad?

If by painting books we mean a book of pictures printed in outline which the children fill in with colour then, in general, these are bad. They are bad because, once again, if the child thinks that you approve of this type of drawing his sense of values may be upset. He may feel that he should try to produce, on the occasions when he is working freely, drawings, paintings of the same kind because he thinks you approve of them. His own innocent vision will be lost and he will be a prisoner of frustration caused by trying to produce drawings beyond his ability, to false criteria, to please you.

A worse danger is that he might feel unable to do any drawing or painting unless he has an outline drawing provided for him first. All that can be said for so-called painting books is that they keep children quiet. They provide no channel for communication, no creative spur and the child expresses little or nothing.

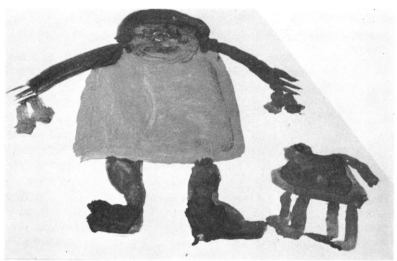

134 'A lady and her dog' by the originator. Age 4 years. Nursery school. 22 × 30 in.

135 'A lady and her dog' by the copyist. Age 4 years. Nursery school. 22 × 30 in.

136 'Brian at the seaside' by the originator. Age 4 years. Nursery school. 22×30 in.

137 'Brian at the seaside' by the copyist. Age 4 years. Nursery school. 22×30 in.

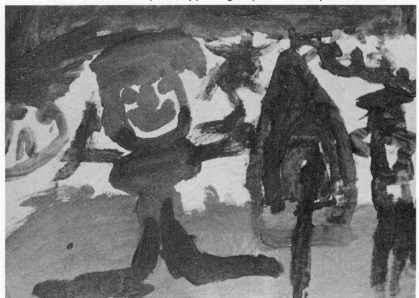

6 Should the child be allowed to take his drawing home?

Yes, if he asks to do so. But try to have a word with mother first. Try to make sure parents understand what lies behind the work. Try to make sure that the work is treated seriously. To those who do not understand, the child's drawing or painting may seem incongruous and amusing. Untold harm can be caused by involuntary reactions, especially if the child is made to feel ridiculous. Unless the child asks to take it home, better to keep the work in school. In any case the teacher should gradually amass a collection of the children's work for reference and discussion. Always keep a portfolio of typical and interesting work.

7 Would you allow the use of stencils or patterns, for instance, for friezes, murals and large-scale work?

No, never. Again the child might form false ideas. He might grow to want stencils for *all* his work. There is a danger that the quick, slick results he gets from stencils might cause him to consider his own freehand methods to be clumsy and slow and so he might suffer a loss in confidence in his own ability to draw or paint.

The most precious attribute which the child possesses is self-confidence. With it no achievement is impossible. Without it he becomes dependent upon the adults with whom he has to deal, or upon class mates. We must above all guard and encourage his individuality and his self-confidence.

As a footnote to this section, the following story will serve to show how easily and unexpectedly a child may be influenced adversely. A mother was proposing to send her four-year-old son to the local playgroup. He was disinclined to go, but finally was persuaded by his mother when she suggested he would be able to paint 'with nice paint and easel and large paper and brushes'. 'What shall I paint?' he asked. His unwary mother suggested a 'bird'. He went happily to his playgroup. Next time he asked for another painting subject and the situation was repeated every time he went. He, in fact, became dependent upon his mother for the initiative to paint. Happily she realised the implications of the situation and sought advice, and the boy was eventually thrown back on his own resources. But this false dependence on his mother was an adverse influence, producing a negative effect on the child.

To the parent

It is a sad fact that parents, so well-meaning, so loving, so self-sacrificing, are often unwittingly guilty of inhibiting and perverting the natural creative abilities of their children. There is a real need for propaganda, and courses of instruction, to help parents to understand the importance to the development of the child of his pre-school years. Some evening institutes run courses on such subjects as 'Living with Young Children'. In these advice is provided which helps parents to understand their children's needs: their need for some form of graphic expression, for instance. Such courses provide some insight into what goes on in the primary school, the implications of the children's art work and the pitfalls to look out for, such as those outlined in the previous section.

Parents are unpaid and, alas, very often inexpert teachers; their shortcomings can sometimes produce attitudes in their children which may persist throughout life – and not all those attitudes are acceptable to society.

Parents, find out about your child – and his needs as a pre-school child and later as a member of his school.

If there is a Parent/Teacher Association at your child's school, join it. If there is not, why not take the initiative and form one. You should take every opportunity to find out what the teacher is doing for your child so that you may complement and reinforce, at home, the good which is being done at school.

One thing is inescapable. You can be sure that your child will want to draw and paint at home, so you must provide for this. The chapter on equipment applies as much to home as to school, so study it. In the meantime, a few general comments of special relevance to the child's painting and drawing at home are included here. They cover basic materials, equipment and attitudes to the child and his work.

Materials

Paint: buy dry powder colours in jars or cans and give the child three or four clean, bright colours. Save domestic glass jars and provide the child with jars half full with powder paint to which water has been added to give a substantial and yet fluid paint. Put a separate brush in each jar of colour and encourage the child to keep them in their right jars; this helps to keep the colours clean and is good training, anyway. You can buy jars of moist poster colours, however they may be more expensive than powder. Large dry cakes of colour, about three inches in diameter and an inch thick, can also be obtained. These are not spillable as liquid paint is, and this is an advantage, but they are not so easy for the younger children to use because the paint has to be scrubbed off with the brush and, as a result, wear and tear on brushes is considerable (though this can be remedied by putting a spoonful of water on each tablet half an hour before use, which will soften it to a 'syrupy' consistency).

You should provide 'finger paint'. This can be made by adding pastes to powder paint or buying the commercial product. In the U.K. Polycell is a suitable cellulose paste. Almost any decorators' wallpapering paste will do.

Mix it to a non-runny consistency. Put about one dessertspoonful of finger paint on a piece of paper, say, 15 × 11 inches.

Brushes

Brushes are important. They should not be too small or too soft. The ideal type is bristle with a round ferrule, about size nine ($\frac{1}{2}$-$\frac{3}{4}$ in.). Hardware stores stock paste brushes and house painters' $\frac{1}{2}$-inch brushes at moderate prices, and these are suitable.

Paper

Rolls of decorators' lining wallpaper are inexpensive and suitable, and can be cut into sheets of a convenient size. The children can paint on newspapers (those with no photographs are best). Newsprint paper, approximately 18 × 22 in., is inexpensive and can be purchased at art supply stores. 'Bank' paper (typing paper) is moderately priced and is also suitable. A ream, 480 sheets, costs comparatively little. If you can afford good paper so much the better, but it is not essential. Any clean paper surface will do. *Make sure that the child has plenty of paper.*

Drawing media

Drawing is as important as painting. Provide as wide a variety as possible of drawing implements: chalks, pastels, wax crayons, oil-pastels, felt-tip markers, ball-point pens. The child will happily experiment with all of these. Remember he has an inborn need to draw. Drawing is a mode of expression, valid in its own right. All of these things, however, will be of little avail unless you take the matter seriously and provide a place for the child to work and some kind of support for the paper on which he is working.

It is desirable that a permanent corner be set apart; a corner where a little mess will not matter. Linoleum or other impervious flooring is ideal, and so are walls which can be washed. In more vulnerable areas of the house a tarpaulin, canvas or plastic sheet affords protection and will enable the child to work without risk of damage to furnishings, carpets and so on. The kitchen is a good place for painting, with its plastic surfaces. Let the child work on table, floor or wall. Do not stifle his urge to draw and paint; give him room.

Some sort of rudimentary easel or drawing board is desirable; the paper should be secured so that it does not slip about. Undoubtedly the best solution is a double-sided easel as illustrated in figure 141. Failing this, a simple sheet of hardboard, or any other thin stiff board with about twelve sheets of paper clipped in position, is adequate. It can be used flat on the floor or table, or can be propped up against a chair or wall.

The attitude of the parent to the child's art work

This is the most important single consideration for you as a parent. Try to cultivate the right attitude to your child and his art work. The following suggestions may help.

138

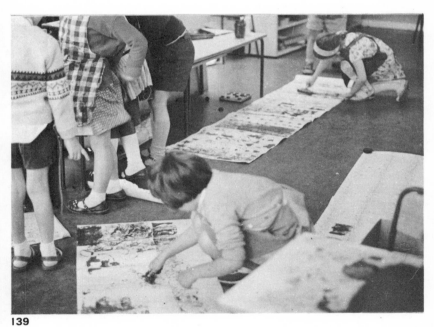

139

140

Remember your child's drawing and painting are much more than scribble and dabs of colour. They are an indication of his personality.

If the child succeeds in communicating to you something of his own personal experience, let him see that you understand and approve.

Remember that your child's thoughts about his drawings and paintings are different from yours. Try to see his point of view and think of his work as that of a young child, not as the work of an inexpert adult.

Encourage him to explore and experiment and to develop his own personal means of expression by so doing.

Resist the temptation to 'help' or 'correct' your child's work. If you do correct it, and if you use adult standards to do so, you will confuse him. Your conceptions are quite different from his. His ideas about proportion, for instance, are different from yours.

Do not take his 'end-product' too seriously; it is secondary to the experience he gains in *doing*.

Do not be surprised at the content of some of his work. It may seem dubious to you, but to him it has significance. Do not show the child how to paint. Give him paint and let him find out for himself. Resist the temptation to draw for him. He is likely to ask you to do so, but try to avoid it if possible. If *you* draw a 'pussy-cat' for him he will think that is the right way to do it and he will copy you. Once he starts to copy you it means that he no longer draws in *his* way, he has given up his own natural way of drawing and has adopted your way. In other words you have made him dependent upon you. It is possible that in future he will be reluctant to paint or draw without a lead from you.

On no account give him colouring books. If you do, this too may make him dependent, i.e. he may grow to feel that he cannot paint unless he has an outline to fill in.

It is wiser not to compare the work of one child with that of another in their hearing. Do not show preference for one type of work rather than another; and be careful not to praise everything the child paints or draws, or he may become blasé.

Keep a close eye on how brothers and sisters treat each other's work. Try to find a way to dissuade one child from interfering with or damaging the work of others.

Finally, remember that every child will respond to an environment containing beautiful, interesting, curious and unusual things. Help to develop this side of his experience by providing him with the richest possible environment in terms of materials, equipment and sympathetic understanding.

In the winter of 1966 I was invited to give a talk to a Parent/Teacher Association belonging to a school in London. The school is situated in a wealthy residential area. I took with me a portfolio of nursery school, primary school and play-group drawings and paintings, many of which are reproduced in this book.

During the course of the talk I said, 'If a child arrives at school at the age of five without ever having been given the chance to use a jar of paint, a good-sized brush and a large sheet of paper, that child is a *deprived* child.'

A friend of mine, mother of three young children, lived in that same area. In the context of this book she would be classed as a model mother because she provides every kind of inducement to her children to paint and draw. The day after the above 'talk' she went to the local art shop to buy some powder paint for her children. 'Madam,' said the shopkeeper, 'I haven't a bit left; I simply can't understand it; I've had a crowd here all morning, and they've bought every bit I had!'

Parents' eagerness to help their children is in most cases limitless; but they need advice.

Organisation

Except in those schools in England which operate an 'integrated day' the usual practice with painting, drawing and crafts in the elementary school is to place them in that part of the daily timetable in which the children have freedom to choose from a wide range of activities. These periods are familiarly known as 'activities' periods or sometimes just 'free activities'. In them, the children are free to choose whether they will play at dressing-up or build with bricks, play with the water or the sand, climb, make things with paper, glue and string; play with clay or plasticine or painting; whether they will bake cakes, try their hand at linoleum cutting, potato printing, embroidery, woodwork, group painting, screen and block printing on fabric. They can, if they wish, tend the hamster or the rabbit or the goldfish, explore the nature table, play in the play house, look at books in the book corner, draw on the blackboard or paint at the easels. Art and craft in various forms are part of the general pattern. The list above is compiled from observation of actual activities in London schools; it could be continued without repetition over several pages. There is no end to what children and teacher together can find to do. It is remarkable what these young children can achieve in even the more sophisticated art and craft activities. Timing of activities periods varies; sometimes they may be in the morning, sometimes in the afternoon.

The duration of active participation in painting and drawing is directly proportionate to the infant's powers of concentration and his interest in his work. It varies, in a general way, in the younger children from about two to ten minutes, give or take a little to allow for putting on and taking off aprons – a necessary precaution! With the seven-year-old children participation may extend to perhaps twenty minutes at any one time and after a break the child may undertake another twenty-minute stint.

Occasionally one sees a group of thirty to forty children all painting together, but this is rare and it would seem to be too much like regimentation for little children who have only limited powers of concentration and a natural tendency to wander round trying everything in turn. The ideal situation seems to be the provision of, say, six double-sided easels at which children can stand and work. If these are left in position all the time, then painting need not be limited to activity periods, children can work when they want to.

I recall one school which is built with six classrooms leading off one long, straight, wide well-lit corridor. Twelve double-sided easels are kept permanently in position against the long wall of the corridor. They are always complete with paper, paint and brushes; the whole set-up is shared by all six classes and there is a constant flow of children into and out of this shared studio. This permissive atmosphere strongly encourages painting. It is not surprising that there is a copious production of rich, vigorous, uninfluenced, significant expression.

Immediate availability of painting as a creative activity is the most important requisite.

Integrated teaching

We hear a good deal these days about integrated teaching. By this is meant the working together of all aspects of the curriculum, the breaking down of subject barriers, timetable barriers, classroom barriers. There is no doubt that total freedom for the child to choose what he will do works. Research by many education authorities throughout the world supports this thesis.

Plowden makes the point that children learn techniques 'most easily when they are needed for the purposes children have in mind'.* In integrated teaching the teacher holds the reins of those activities which stir the children to create. For their purposes of creation they will learn the skills of writing, making, speaking, painting and so on. In the course of a project on 'My Town', for example, a child may paint a model fire engine red, but this is not necessarily a very deep experience of colour. Experience of painting red, the experience of red in depth which only painting as such can give, is also necessary. In our keenness to integrate our teaching we must not forget there is also a need for experience in depth. There may be undesirable con-sequences if learning is limited to only those experiences which 'happen to arise' out of working to specific themes or projects. It is conceivable that whole ranges of activity may be missed out accidentally. For example, if the themes used were based mainly upon three-dimensional techniques this could result in the virtual exclusion of drawing as an activity. If we accept, as I am sure we should, that drawing means seeing environment, analysing environment, and thereby learning to identify with environment, then children at seven years of age, i.e. those most likely to engage in this kind of activity, will be deprived of the benefits which derive from drawing because of the too great emphasis upon three-dimensional technique. But this is not a serious risk. It is hardly likely to arise at the seven-year age level and it will not arise at all with the five-year-old.

Happily, by his very nature, the young child (especially the five-year-old) is a self-integrating creature. He loves to dodge about all over the room and around the school, and sample a bit of everything. In sampling he may well find a deep interest in one special activity and from this deep interest new experiences will lead on to new explorations.

Equipment

The availability of art equipment to schools varies from place to place and between one authority and another. Under this heading it is only possible to suggest basic types of equipment. These are:

Easels (double-sided for economy of classroom space) with a shelf tray at the lower edge to hold containers or jars of paints with brushes.
 Wire trays to hold paint jars and water jars.
 Glass jars to hold paint and water.
 Bristle brushes sizes 8, 10 and 12 (about $\frac{1}{2}$ to $\frac{3}{4}$ in.).

* *Children and their Primary Schools*, Volume 1. (H.M.S.O.)

Aprons or smocks.

Metal clips, clothes pegs (pins), for quick attachment and release of paper.

The illustration in fig. 141 shows a double-sided easel of suitable design. It stands approximately three feet in height, which is a good general size for small children. Most of them like to work standing at easels. This easel has a rack shelf at the lower edge of the working surface into which glass jars will fit. The easel is hinged at the top for ease of storage. A good pad of paper is held in place by metal clips; this allows for rapid provision of clean paper (young painters are voracious consumers of paper). This type of easel is simple in design and it can be made quite easily, if supplies cannot be obtained from your education authority.

In addition to easels there should be plenty of tables (preferably Formica-topped as they are easier to keep clean) and horizontal surfaces at a convenient height, for the children to work on. These are particularly useful for group work, as for this activity they can be placed side by side or in formation. Walls and floors can be brought into service as required.

A small woodwork bench with a vice is highly desirable in each classroom (fig. 142).

Fig. 141 This easel is well suited to the needs of the infant child. It is of a suitable height, and the rack-ledge provides a handy place, at an easy height on which to rest pots of paint. Paper is held in place by a metal clip, or clips, for quick replacement.

Fig. 142 Children's bench; this is standard equipment in London and is supplied by the Inner London Education Authority. Similar benches are supplied by other authorities.

Fig. 143 This shows various types of clip in use. On the left metal clips, in the centre two different types of domestic clothes pegs, on the right a 'bulldog' clip. Any of these will serve to hold paper in position on the easel.

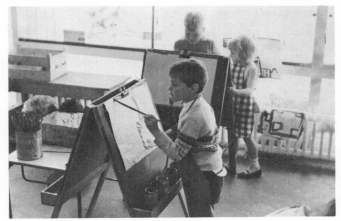

141

142

143

Materials

It is best to keep sets of three or four bright colours always ready. Use glass jars, one-third full of powdered colour mixed with water to the consistency of cream. Children enjoy clean, bright colour. In order to keep the colour clean as long as possible each jar should have its own brush, and care should be taken to see that each one is used only for its own colour. The consistency of the paint should be such that if painted on a vertical surface it does not run down, but it should be thin enough to apply easily. It is a mistake to mix it too thin as brilliancy is lost.

Powder colour mixed with water or poster paint (in the U.S.A.) is better for young children than solid colours in tablet form. Liquid colour is more immediate in use. The child is an impatient creature. He wants a quick result and this is not so easily obtained if he has to scrub on a tablet of colour to charge his brush before he can paint. In the top grades of the infant (elementary) school the children will be able to manage palettes of dry powder colour and do their own mixing. The teacher will decide what is best for her situation.

Large wax crayons are available and should be provided. These make strong line drawings and children enjoy using them.

Paper

This is likely to be an expensive item in the primary school. For this reason cartridge paper is out of the question. Manila paper, cream, grey or white 'brushwork' paper or wrapping paper is ideal. Newsprint is moderately priced. There is a case for using newspapers to paint on if sufficient quantities of the right kind are available. The most suitable are those pages with no photographs, for example, *The Times'* advertisement pages.

Ordinary one-pound jam jars (or coffee cans) are very useful for paint and water, though in the U.K. many authorities supply their own special jars. Glass jars, in spite of slight risk of breakage, are to be preferred to the annoyingly lightweight plastic substitutes which tip over much too easily.

Brushes

Sizes 8, 10 and 12 ($\frac{1}{2}$ to $\frac{3}{4}$ in.) bristle of good quality are suitable general-purpose brushes. Brushes are used vigorously, so good-quality bristle is advisable. Cheap brushes wear out much more quickly and there is no saving in the long run.

The main point to remember is that the materials and equipment should be readily available. The children should know where they are and should be encouraged to get them for themselves, and also put them back after use, except those kept with the painting easels.

Materials for crafts

There are so many materials for crafts it is not possible to mention them all here. In any case, as I stated in the foreword, this is an examination of

drawing and painting, not an attempt to review the whole field of creative art and craft activities. The needs arise out of the work in progress. Many of the materials will not be available in educational supplies catalogues for the obvious reason that they are to be found free in the environment of every school. They can be had for the trouble of collecting them. For those that are on offer by the suppliers, lists can always be obtained. The firms concerned are very ready to send details of prices and varieties.

It is not the aim of this book to look in detail at specific media and this applies especially to crafts. Useful handbooks are available to help teachers.

Group work

It must not be thought that the earlier reference to art in activities periods, under the heading 'organisation', implies that there is a particular time and place for art activities. The widest possible freedom which fits into the teaching pattern should be encouraged. In many schools, the boys and girls work with papers fastened to wall or display boards, with large papers flat on the floor in the assembly hall, along the corridors, on tables, etc. Different jobs and projects call for different facilities and experiment. Innovation should be encouraged. Large painting needs large supports to work on. Special supports for paper can be constructed with wood strips and pulp board; these should be tried.

Seven-year-old children need no encouragement to work together in groups. They are always ready to 'help' each other. The labour force employed on any one picture is likely to vary from moment to moment as excitement and interest wax and wane and the children flit about from point to point.

The one constant in all this is the value of the activity itself. Group activity helps the child to adjust to his classmates, helps him to assess the other child's point of view, to match his capabilities with others, to pit his wits and his *personality*. By this exercise he learns to adjust to society. This makes for a class of adjusted individuals and so to an integrated group.

At the present time an increasing number of British schools are adopting the system known as family grouping (see page 51), a method of grouping the children 'vertically' rather than 'horizontally'. This means that, in a school with six classes, instead of two classes of five-year-old children, two classes of six-year-olds, and two classes of seven-year-olds, there would be six classes, all of which would contain a cross-section of the age range. As each child arrives at the school for the first time he, or she, is assigned to the teacher and class where he will usually remain during the whole of his elementary school career.

There are considerable advantages in this system. It means he will suffer fewer disruptions due to change of class and change of teacher. He will feel settled and secure. His friendships will have time to mature. He will have the benefit of observing the skills and attitudes of his older fellows. The older children, the seven-year-olds, will learn from a situation in which they will develop a sense of responsibility towards their younger class-mates.

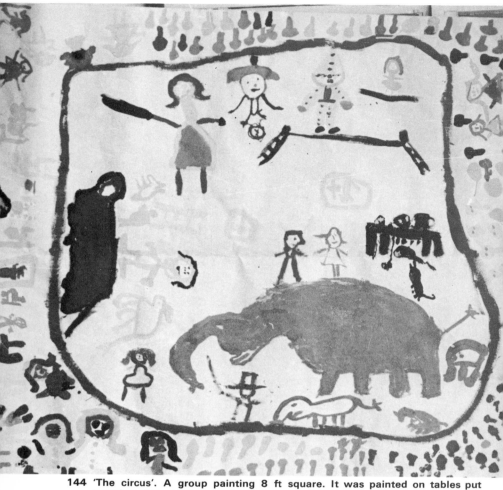

144 'The circus'. A group painting 8 ft square. It was painted on tables put together. The children worked all round. Age 6 years.

145 'Railway and people', another group painting. Age 6 years. 42×96 in.

Observations in family-group schools reveal no serious disadvantages from the point of view of drawing and painting. It might be expected that the older children would influence the younger, but this does not seem to be the case. After all, the situation in a family-group class is the same as in any home where there is a group of children of different ages. In the school situation there is safety in numbers. Personality counts for much. A forthright five-year-old may well influence his seven-year-old colleague. It seems, as to drawing and painting, there is no more and no less influencing and copying in the family-group school than in any other school organised on traditional lines.

It will be seen that a number of the illustrations included in this book are of work produced in family-group schools.

Exhibitions of child art

A young, able art teacher said recently, 'I feel rather depressed. We didn't get any pictures into the Children's Exhibition this year. I am beginning to wonder whether I am failing the boys and girls.'

The work on the walls of her art room was lively and expressive. The teacher was enthusiastic and sensitive. There was nothing wrong with the work, the children or her teaching. Her depression was unfounded and unnecessary.

The first important exhibition of children's art in Great Britain was held in London in 1908*. It comprised works by pupils of Franz Cizek, a pioneer student of children's natural graphic expression. He was a student and later a professor at the Academy of Fine Arts in Vienna. He observed and became deeply interested in the uninhibited drawings with which young children covered the pavements and walls outside the house where he lodged while he was a student, and similar examples which they produced when he allowed them to use the paints and pencils which he kept for working in his lodgings. What interested him most was the intensity of expression in their style of drawing. He was struck by the difference between the vigour and panache of the uninhibited drawings in the street and the tight, restricted unnatural academic drawings which the boys and girls were called upon to produce in school, if they were lucky enough to have art classes at all.

He organised a small class for these children. He encouraged them to draw freely and in the manner they felt inclined to use, in whatever medium they preferred, using their own images and relying upon their own imagination. Cizek may fairly be said to have been the liberator of the child artist. His children's class became famous and gave rise, sometime later, to the exhibition mentioned above.

At the time it attracted a good deal of attention and added weight to the theories of such men as Ablett and Catterson-Smith and encouraged such official bodies as the Board of Education to suggest experimental techniques of teaching art. It drew attention to the fact that children are not just small or immature adults; they are individuals with their own personalities and their own way of expressing themselves. It helped educationalists for the first time to realise that children are not mere imitators, but are creators. Cizek believed that every child has a unique personality and should be encouraged to develop in his own personal childish way at his own speed. Rigid teaching, contrary to this, tends to force every child into the same strait-jacket. Adult standards must not be applied to the work of children.

These were Cizek's ideas towards the end of the nineteenth century. They are now universally accepted, and it is to a large extent due to the influence of the above exhibition and others like it in Europe at the time, that Cizek's ideas spread and became recognised. That exhibition then was a good thing.

The situation today is very different. The revolution which began with

* See *Children as Artists* by R. R. Tomlinson.

Franz Cizek continued, in England, for example, with Wilhelm Viola, Marion Richardson, Barclay Russell, Herbert Read and the Society for Education through Art is almost complete. It is now accepted in most countries that the child has his own form of expression in every medium and especially in art and craft. This argument has been put and accepted. Propaganda in the form of exhibitions of children's art is no longer so necessary. The exhibition of child art has served its turn and yet such exhibitions continue and proliferate. They continue because children's art work is almost always charming and colourful and frequently unexpected and amusing in content. They continue because commercial firms exploit the idea and because art critics persist in taking them seriously and comment upon them in the same breath as they discuss the current professional exhibitions in the galleries. That which began as serious educational research has degenerated into a social cliché, persisted in for the wrong reason and misunderstood by the children, the teachers and the public alike. More than this, it is possible that positive harm may result if inexperienced teachers see these exhibitions as fountains of ideas to copy. The child's work is a by-product of educational activity and may indicate little or nothing of what happened during that activity. It may give no clue to the experience which accrued to the child during the process of its production. It may illustrate the letter yet not indicate the spirit of the art teaching.

Damage could arise if teachers began to coach their children to produce work specially for the selection committee. Children may feel a sense of failure if their work is rejected by a selection committee. Children may feel that they have fallen short if they fail to win a prize. Can one be sure of the selection committee: who selects the selection committee?

So-called painting competitions organised by commercial firms should be prohibited by law. They are rarely if ever organised and judged by educators. If they are not educationally valid there should be no place for them in our schools.

Having said all this, there *is* a place for small intimate exhibitions within the school, on 'open days' for instance and for ordinary days about the school corridors, assembly halls and classrooms. Children's paintings and drawings well displayed will enliven any school interior.

There is a place for exhibitions of child art as visual support at conferences and seminars where art in schools is under discussion. I recall a remarkable example of such an exhibition at Birmingham University. Not one pretentious picture, but instead a scholarly exposition in visual terms of the philosophy of education through art, every piece of drawing an essay in visual exploration and discovery, every painting evidence of delight in texture and colour, everywhere indications that art had been used as a means for 'education by experience' of a significant kind.

147

146

148

149

150

146 Two different types of staple-gun or 'tacker' and a 'push-pin or ram-pin'.

147 Using the 'tacker'; a quicker and more efficient method of mounting an exhibition.

148 The 'ram-pin' has a magnetised barrel; steel pins do not fall out.

149 Loading a dressmaker's pin into the barrel of the 'ram-pin'.

150 Pushing home the pin with the 'ram-pin'.

Display

Wherever children's art work is displayed, it should be well displayed. Whatever the purpose or scope of the exhibition, care should be taken in mounting it. Nothing looks worse than higgledy-piggledy collections of paintings and drawings with their corners hanging loose, mounts of disharmonious colours, borders too wide.

Greater harmony will be achieved if pictures are given narrow half-inch mounts of neutral colour, grey, white, off-white, pale cream. It will also help if drawing pins (thumb tacks) are avoided; the heads are too obtrusive. There are other methods of attaching paintings and drawings to display boards. One is by means of a 'push-pin' and dressmakers' pins; the pins are almost invisible. The other, and probably the best, method of fixing work to the display board (of which there should be ample areas in all classrooms, corridors, assembly and circulation points) is by means of a staple-gun. These are quick and efficient and the staples are almost unnoticeable in use (figs. 146 to 151).

A little practice will enable the teacher to achieve a good standard of display. Cleanliness and tidiness are the essentials. Harmony is achieved by relating all verticals and keeping them parallel and by taking care to see that all horizontals coincide or relate to one another. Sticky tapes should be avoided if possible as they never look tidy.

Good display will give distinction to an interior and it will start the child off in the direction of good standards.

151 This illustration shows how much less visually aggressive are pins and staples than the old-fashioned drawing pins.

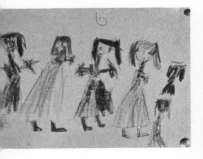

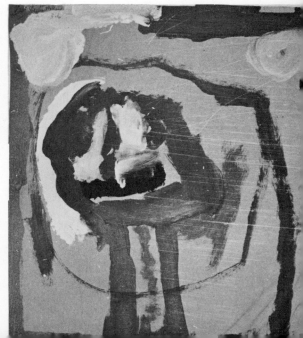

Standards

The question of standards is one which will exercise all teachers. Only the highest standards are good enough for little children, who are learning so much so quickly. There must be good standards of hygiene, behaviour, lighting, ventilation and all the other routine and physical aspects in the school, and amongst these are the aesthetic standards of display, decoration, presentation, colour schemes, personal dress.

Young children notice everything and what they don't consciously notice is borne in upon them and will help to found a code of good standards for later life.

It does not require much imagination to see the advantage to the classroom environment of a tidy nature table. A sparkling goldfish tank looks so much more attractive than a muddy one. A sweet-scented mouse cage is easier to live with than a malodorous one. Live flowers decorate – dead flowers depress. Fresh display boards attract, dingy ones repel; white painted pin-up boards help the atmosphere – pockmarked cardboard-coloured pin-up boards reduce the decorative power of even the strongest work.

Influences

The influences which bear upon the child are as numerous as the experiences to which he is subject. Parents, teacher, home, school and everything which happens, and is contained, there; everywhere he goes, everything he does, all provide experiences which influence him one way or another. The teacher will understand the child better if she is aware of the major influences in his life. It is for this reason that the child's art work should be taken seriously because, by its content, it goes a long way towards indicating what these influences are. The following list of titles given to paintings in my collection by children reads like a social commentary:

A house falling down
A bad man
A police car in the snow
Raining on the houses
A boy with chicken-pox
Mrs Grubb went to the dentist
A lady lying in bed
A thunderstorm
Men catching birds to take away to another country
A man playing a piano
Two men in space
A lady with her baby
All the leaves coming down
A painting about Sunday
A man sweeping the leaves
A bad dream
Peter in his school hat with the button
The little girl is covered with stars
Susan skipping
Brian at the seaside
Baby and a cot
Two little boys
A tree on a windy day
A girl with a hat
A flower by a house
Christmas cake
A caravan/trailer
A radio
A lady with her dog
A cat
An old-type elephant(!)
Two houses
Tree, house, mummy, little hut, boats
Carol's mummy and daddy
Samuel in the temple
James Bond's girl friend

An important part of the process of educating the young child consists in discovering beneficient influences and using them. For instance, teachers will endeavour to extract every bit of advantage from the good parent and the good home. By the same token the teacher must try to counteract harmful influences and unhappily some of these may sometimes come from those same good parents, who can unknowingly so easily influence the child adversely. Cases of this kind frequently arise when children take their art work home. The thoughtful teacher will encourage parents to visit the school and to look at art work in the classroom. She will explain a little to them of what it implies and impress upon them that the 'end product' is not the important thing; that what really matters is what happens to the child while he is carrying out the work. The teacher can help if she can impress upon the parent the damage which can be done to the child by incautious comment upon the child's work – such as the involuntary laugh at the incongruity of the drawing. The more the parent of the young child can be persuaded to liaise with the school the better.

The attitude of parents to the work their children bring home is a more powerful influence than many other aspects of the child's environment which are so often blamed for so much. The mass media, for instance. Of course television, newspapers, comics and advertisements make their impression, but young children absorb many of these impressions and give them out again in their own terms. They absorb them as part of their overall experience, and the content of their drawings gives no indication that television has an exaggerated influence in their lives at this age. Children quite readily invent symbols for television and also for a good many of the images which television brings into their lives, but it seems that at this age they are relatively unharmed by the pernicious content of much of the visual matter which is presented to the general public.

The teacher of course is, or should be, the major influence in the child's school life. She will influence by example; by the richness or otherwise of the physical environment she creates in the classroom; by the opportunities for activities she provides; by the careful watch she keeps on the interplay of personalities within the group; by using her judgement to make sure that a balance of influence is kept, of child upon child within the group. Children influence each other to a significant degree.

The teacher's influence is felt in another way. She must be the children's guardian against poor standards. She must be sure that books with shoddy or over-sentimental illustrations are not provided for the children. She must aim at high standards of decoration and display in the school. She must make sure that 'professional pictures' are worthy to hang on the walls.

Education authorities in many counties in the U.K. have collections of original pictures to lend to schools, and primary schools are included in this. The Inner London Education Authority has a very large collection of contemporary painting. In their experience young children show a marked preference for bright-coloured paintings and of this kind 'abstract paintings' are particularly popular.

It is never too early to begin to introduce young children to works of art. A school in London makes a practice of taking small children to see the modern collection and exhibitions of contemporary art at the Tate Gallery. The pictures in figs 155, 156, 158, 159 and 160 show paintings produced by children aged five, six and seven after a visit to the Tate Gallery.

152 'Men catching birds to take away to another country' (the child's own title). Age 6¾ years. 12 × 15 in.

153 'The Pool of London' by André Derain, 1906. Oil on canvas. 26×39 in. Tate Gallery, London. The children saw Derain's picture when they visited the Tate Gallery. They also saw the actual riverscape.

154 'Whaam!' by Roy Lichtenstein. 1963. Acrylic on canvas. 68×160 in. Tate Gallery, London.

Fig. 154 'Whaam!' had considerable impact upon this boy. Back at school he reconstructed his experience of the picture in the way you see here. Was this a good or bad influence?

155 The children's version, produced as a result of the two experiences above.
 Age 6 years. 22 × 60 in.

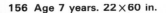

156 Age 7 years. 22 × 60 in.

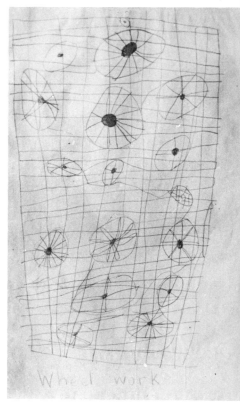

157 'Torso' by Harry Kramer. 1962. Kinetic sculpture. 45×26¾×27 in. Tate Gallery, London.

158 Child's drawing made at school after seeing Harry Kramer's 'Torso' at the Tate Gallery. Age 6 years. 22×15 in.

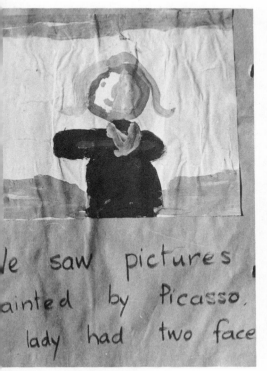

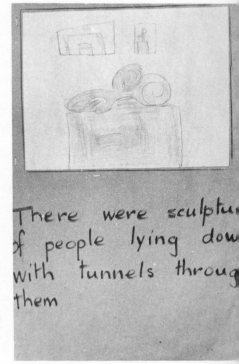

159 Age 6 years. 12 × 14 in.

160 Age 6 years. 10 × 14 in.

Fig. 159 The young child readily accepts Picasso's 'instantaneous vision' and sees nothing strange in the face seen in full-face and profile at one and the same time.

Fig. 160 Another example of a child's work after a visit to the Tate Gallery in London. The caption is legible and speaks for itself (caption written by the teacher).

The teacher must try by all means to avoid the bad influence of books which contain inappropriate illustration material. As Lowenfeld points out in *Creative and Mental Growth*, to use a symbol ⌒⌒ to represent a bird in books on number is to confuse the child.* The case he quotes shows the total corruption of one young child's vision by this means. No child of five to seven would spontaneously represent a bird like this. Look at the picture in figs 161 and 162; 'pin men' are sometimes used and are a parallel case. Educational publishers would perform a valuable service to the community if they would examine this matter carefully.

* *Creative and Mental Growth* by Viktor Lowenfeld and Lambert Brittain.

Fig. 161 'Pigeons' by a small group of five-year-old children. This picture and the version below in fig. 162 by two seven-year-old children were produced in the same school as a result of the following incident.

The mobile 'tuck-shop' paid a visit to the school gate and sold bags of potato-puffs to the children at lunch time. The children discarded the empty bags in the playground, causing a good deal of untidiness.

The headmistress decided something should be done about inculcating good standards of behaviour and tidiness. She asked her staff to take all the children up to the long first-floor corridor which looks out over the playground. From there, she thought, the visual impression of the litter would be very clear to the children. 'When I clap my hands,' she said to the teachers, 'throw up the windows and tell the children to look out.' She clapped her hands, the windows shot up, and the children looked out; just in time to see clouds of pigeons (which had been pecking potato-puffs that the children had dropped) startled by the noise made by the windows. They rose all at once and fluttered across the sky, past the windows up into the air. 'Ooooooo!' chorused the children, 'what a lovely lot of birds! Miss, can we paint them?' A session of painting followed and these are two of the pictures which were produced. The headmistress has a rare understanding of the value of creative painting and drawing. She thought the moral training well lost to this exquisite visual experience of sunlight seen through beating white wings, and wheeling rhythmic patterns and the sound of wings in the air. She knew that such experience would lead to creative expression in all sorts of media. She was right.

The two pictures provide an interesting comparison of the powers of expression of children at the opposite ends of the age range of the school.

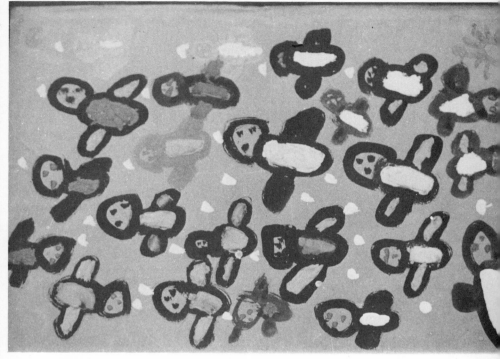

161 Age 5 years. 22 × 30 in.

162 Age 7 years. 44 × 60 in.

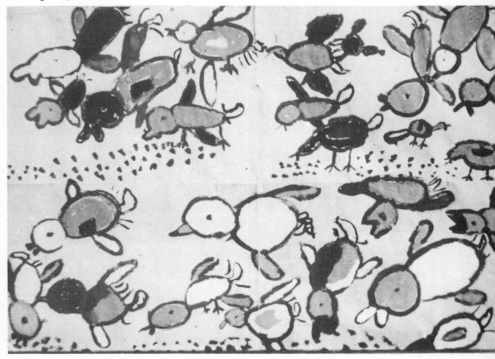

We have mentioned the stencil before. These cardboard silhouettes of animals, etc., round which the children run a pencil to produce an animal outline are, or should be, a thing of the past; as is the teacher's drawing on the blackboard for the children to copy.

It is gratifying that there is little evidence of the use of colouring books in schools, as this is perhaps the most damaging influence of all to the child's creative growth. We have discussed earlier how, faced with an outline drawing the style of which is completely foreign to him, the child sees no connection with his own imagery. If he deems the colouring of these outline drawings to be what the teacher thinks is good art, he will seek to please her and in so doing will become dependent upon this process. He will grow to need an outline to fill in because his own drawings are not like this, are not 'good enough'. He will lose his own initiative, his own childish vision.

To deprive or pervert a child in this way is an act of unforgivable inhumanity.

The child's own individual mode of expression is his most precious attribute in the sphere of creative expression. It is also the most fragile and sometimes the least understood of his activities. We must strive at all costs not just to keep it alive, but to nurture and encourage it.

In general the young child is one hundred per cent teachable, one hundred per cent willing to accept and act upon what the teacher says. He is unendingly eager to please. The responsibility this places upon the teacher calls for perpetual vigilance to avoid submerging the child's personality, and constant self-examination to make sure that the teaching encourages the child's own natural creativity. The acid test for the teacher, parent, playgroup leader, is to ask each time, Will this particular method, this idea, this lesson, this activity, this 'painting game' produce a stereotyped end-product from each child?

If the answer is 'yes', or even 'probably', it means that the activity in question militates against the individual growth of each child by stifling his own personal mode of expression, by putting him into a strait-jacket, by setting up a procedure which he is called upon to follow to a pre-determined end.

Left alone, every child will draw a bird, for example, in his own personal way. If the teacher draws a bird on the blackboard the children will all draw it the same.

If the method produces identical results, if the idea influences the children too strongly, if the lesson conditions their thinking too directly, if the 'painting book' results in a filled-in outline; in other words, if the result of the method is regimentation and uniformity, then it is bad, educationally.

Crafts: a change of emphasis

A child was given a piece of soft pottery clay by the teacher and left to play with it. He squeezed it, pinched it, enjoying its clay quality. After a time he found an ovoid shape developing in his hands. He watched the clay take on a personality, or he invested the shape with a personality, 'mother', 'father', 'man', and from this a fantasy situation began to develop. The human form which was the result is shown in fig. 164. It is an exact three-dimensional equivalent of the drawn or painted 'big head' figure we already know.

As soon as this modelled 'big head' figure is found the communication activity begins, in the same way as it did when the child found the oval in his scribble. The child will talk to the model, he will talk about the model to the teacher. He will soliloquise, discuss, exchange ideas, converse with the model. Part of this will be verbal explanation to the teacher; here again is another beginning of creative, imaginative, verbal expression, generated by

163 'Big-head' figures made from pastry. Age 4 years. Approx. 4 in. long.

164 A composite 'big head' figure made from clay, cotton wool, twigs and lollipop sticks. Age 5 years. Approx. 5 in. across.

the child's fantasy play, by himself, with no active teaching by the teacher, arising spontaneously out of the act of handling and manipulating the clay. The teacher will try to catch something of the child's fantasy and translate it into permanent form; this is usually done by writing the child's title on his painting or drawing. It is not so easy to carry out this procedure with modelled objects. As we have discussed earlier, the system of writing the child's own brief description or title on his work is a way of linking concepts in the child's mind; it links concept with activity, activity with object, with spoken word and with the written symbol for the spoken word. Perhaps most important of all is the fact that the activity of modelling will provide a tactile experience; the tactile experience produces a three-dimensional form which in turn invokes fantasy; it generates ideas — it exercises the child's powers of imagination. The total value of all this is that it provides the teacher with an opportunity for channelling these youthful energies towards a situation in which the child will be even readier to express his fantasy in words. As we have said before, this is the first step towards verbal discovery; and its source is in a creative art activity.

The link between art and craft is so close that they are virtually one and the same, and yet each and every subdivision, painting, drawing, printing, modelling, carving, collage, makes its own particular contribution to the experience of the child. There is a subtle difference in emphasis in their application and effect in the school. Let us take an example of this difference between so-called art and so-called craft. Let us look at an example related by the clay to the 'big head' figure we have just been discussing.

The situation begins, as that one did, when the child is handed a piece of pottery clay. This time, instead of leaving the child to himself to play with the clay, he is shown how to make a coil pot or a thumb or pinch pot. As before he has the excitement of feeling and manipulating clay, but this time he is subject to disciplines outside himself. Firstly the discipline of doing what is suggested by teacher, and secondly working within the discipline of the nature of the clay itself. In working freely, as he did in making the little figure, he was subject only to his imagination, his self-discipline and the discipline of the material. You will see he added materials to his model by his own inventiveness (fig. 164).

In the second case, in making the pot he was not working freely, but towards a requirement outside himself. The discipline of the material itself was the same, but the requirement of the 'lesson', i.e. to make a pot, precluded his adding to and manipulating his medium for his own purposes. A pot is a pot, and as such, less evocative of fantasy than the model of the human figure.

There is significant experience in both these activities: making the figure spontaneously and making the pot for teacher; but these two experiences are different in *kind*. They might be summed up as, in the case of the figure, 'imaginative growth', and in the case of the pot, 'coming to terms'. It is for the teacher to decide at what stage of the child's development the one or the other or both of these two types of experience are appropriate.

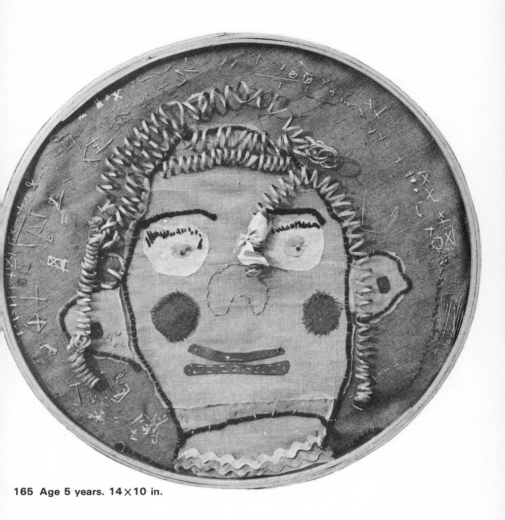

165 Age 5 years. 14×10 in.

Fig. 165 A mixture of appliqué, collage and embroidery made this figure. Children enjoy this kind of activity, though at this stage they tend to produce figures or other symbols which conform to their previous experience in painting and drawing — with the same purposes in mind.

166

On one occasion, a group of six-year-olds was making ships from cardboard boxes and glue. This was a craft activity 'with requirements'. The resultant fleet displayed the usual diversity of ability in managing the medium, but the interesting feature of the lesson was the emergence within half an hour of a group of rebels who had lost interest in the craft lesson and detached themselves. They then took possession of a large shallow cardboard box, big enough to hold two sitting boys (fig. 112). This became a ship which, in the short space of the next ten minutes, sailed to Australia, was attacked by pirates, was wrecked and was set on fire, and incidentally was fitted with bamboo-cane masts and string rigging and decorated with paint.

Another difference between art and craft is that, by its nature, craft may tend to lay emphasis upon the quality of the 'end-product'. Care must be taken not to stress this at the expense of the educational value to the child of the experience gained in 'doing'.

In crafts, as in art, the end-product may give little indication of the value gained from the activity itself, of what happened to the child as a result of his participation.

Plates

The plates which follow have all been chosen because they illustrate points which have been discussed in the text or because they amplify, or clarify, or extend, some of the arguments.

All of them were collected either from primary schools, from nursery schools, from nursery classes or from playgroups. A few were begged or borrowed from friends who are parents of young children.

Fig. 168 This lively drawing was produced by a nursery-school child. I was amused by the large red eyelashes with which she had endowed her mother.

The teacher said she had been amused, too, but that shortly after the drawing was made the child's mother came to school to fetch her daughter home. The mother was wearing dark glasses, which was a little surprising as it was the end of the afternoon on a dull cold December day.

'I expect you are wondering why I am wearing dark glasses,' said the mother to her child's teacher. As she said this she removed the glasses. 'That's what happens,' she said, 'if you get too near when you open a hot oven.' Her hair was singed, she had no eyebrows, and no eyelashes.

It is not difficult to imagine the child standing expectantly by her mother's side, waiting to see the cake, or whatever it was, cooking. Instead there must have been a waft of searing heat, billowing smoke, and a cry from mother as she reeled back, hands to face, her eyebrows and lashes burnt.

The child's picture, in this context, takes on a different significance. It is not, now, a subject for knowing smiles about feminine vanity, and false eyelashes. This was a harrowing experience for the child. She has played out the terrifying scene again in her drawing. The significance of the red eyelashes is now apparent.

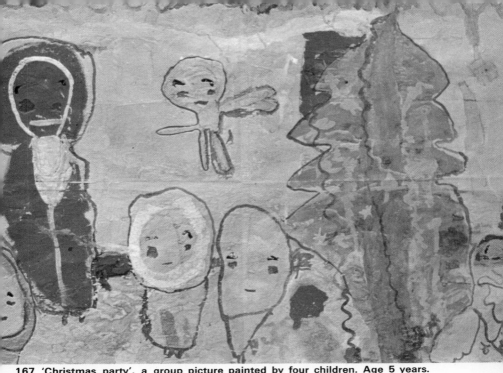

167 'Christmas party', a group picture painted by four children. Age 5 years.
44×60 in.

168 Age 4 years. Nursery school. 22×30 in.

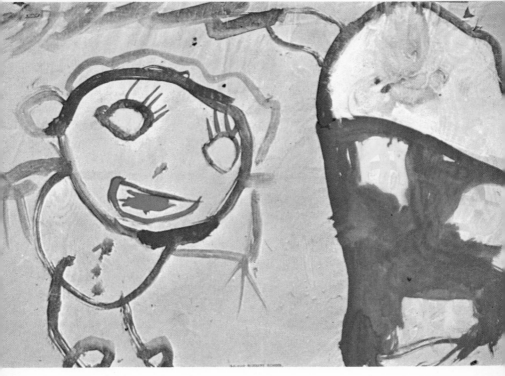

169 Two seven-year-old boys using 'junk' materials to make a pattern; the unit is the egg box, sometimes painted, sometimes not.

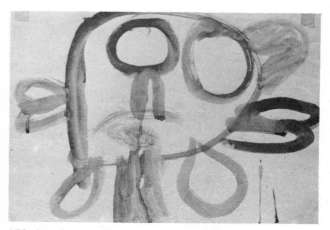

170 Age 4 years. Nursery school. 15 × 22 in.

Fig. 170 The child who made this drawing is at the 'big head' stage. It is Christmas time. The 'big head' is drawn in red, but apart from that it is very like any other 'big head' even when the beard is added; but in spite of this, the child is quite sure about the identity of the person in his drawing. Who else could it be at the end of the winter term but Father Christmas or Santa Claus?

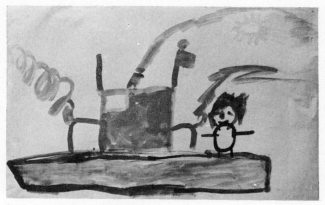

171 Age 5 years. 20 × 30 in.

172

Figs 171 and 172 These two paintings of ships were produced by a five-year-old boy. It took him about six or seven minutes to complete the first. When he had finished it he took off his apron and went out into the playground. He decided to take a ride on the tricycle. As he reached for it another, bigger, boy decided *he* would take a ride too. The bigger boy won. The loser was furious with rage. He went back into the classroom, seized a brush and painted the second ship (fig. 172).

On pages 136/137.

Fig. 173 'Christmas cake.' This and the following illustration (fig. 174) are examples of 'patch' paintings; they are very similar in style and in the way the paint is applied but, as their titles show, the interpretations put upon the paintings by the children are very different.

Figs 173 to 175 Figs 173 and 174 are clearly 'patch' paintings. Both show sensual enjoyment of colour and paint and when the paintings were finished the children looked at what they had done and their imaginations 'discovered' the content: 'Christmas cake' and 'My house'.

Fig. 175 shows a similar way of applying the paint, i.e. in 'patches', but in addition it shows how a very little extra manipulation and control renders the statement more explicit − yet the picture is still a 'patch' painting.

Fig. 176 This rich piece of pattern was made by a four-year-old child who 'grew' it by the simple device of adding small semi-circular forms, one to the other, in rows. Young children seem to have a built-in gift for, and enjoyment of, making patterns of all kinds.

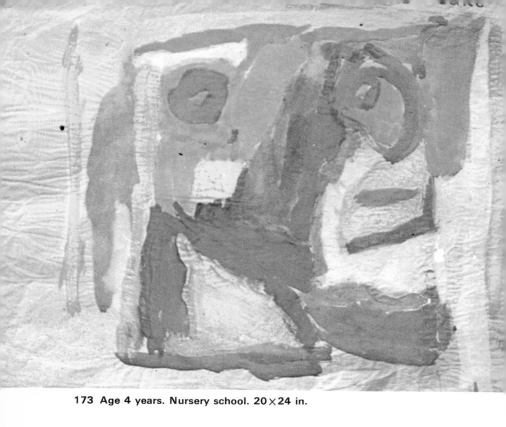

173 Age 4 years. Nursery school. 20×24 in.

174 'My house'. Age 4 years. Nursery school. 20×24 in.

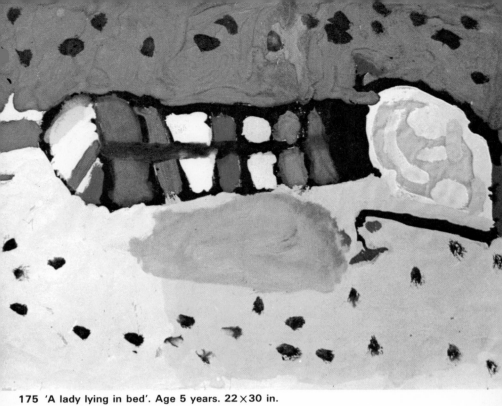

175 'A lady lying in bed'. Age 5 years. 22×30 in.

176 Age 4 years. Play group. 18×12 in.

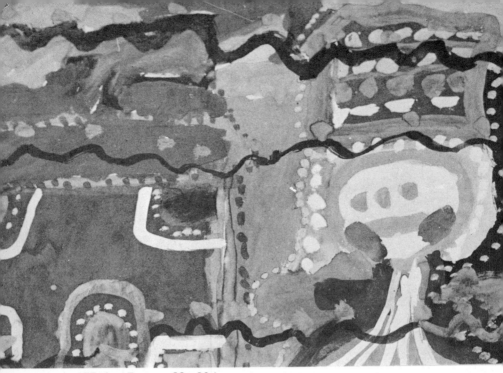

177 Age 7 years. 22 × 30 in.

Fig. 177 A seven-year-old child painted this poetic composition. She gave it no title. It is an extended version of the 'patch' painting and is not closely related to reality. It is, in my experience, an unusual and rather mysterious painting.

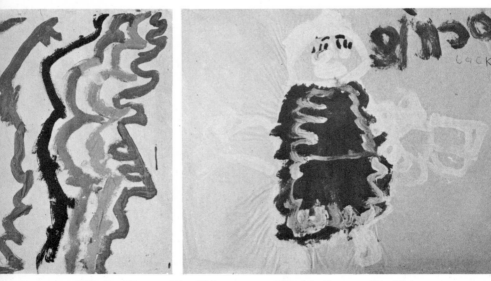

178 Age 5 years. 24 × 16 in. **179 Age 5 years. 18 × 24 in.**

Figs 178 and 179 These two illustrations show two paintings by Jackie. The first is a simple pattern based on linear rhythms. It is in fact a modification of the stripe type of 'patch' painting. The second is a simple figure to which she has added the pattern with which she had been experimenting a few days previously. This process of marrying together two processes seems to indicate development forward and an increase in the ability to organise ideas.

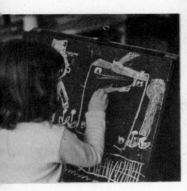

180 **181**

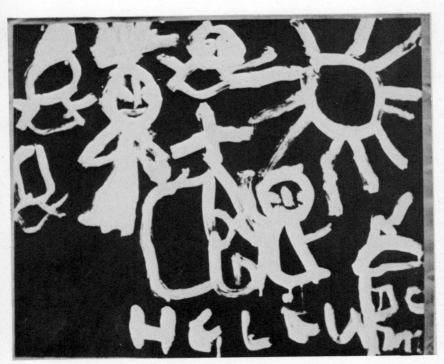

182 Age 4 years. Nursery school. 22×26 in.

Figs 180 to 182 Children draw instinctively. They will draw anywhere any time. Drawing is one of the most creative forms of expression available to the young child. Even when they paint they draw; they use the tip of the brush to produce a line. This is a quite different process from the frustrating system of 'drawing first, and filling in with paint afterwards' which is still encouraged, in some places.

183 Age 3¼ years. Nursery school. 18 × 14 in.

Fig. 183 This remarkable variation of the 'big head' was painted by a boy of three years three months. Both his parents are professional artists. This seems to point to the effect of environment on the speed at which the child develops.

 The technique used in the painting of this picture is sophisticated, consisting as it does of colouring the background all over first and then placing a line drawing on top. This is a quite exceptional painting. It is unlikely that many equal to this in calibre would be encountered in the ordinary run of things.

184 Age 6 years. 22×30 in.

Fig. 184 This picture is a classic example of children's painting. It contains all the elements that have been discussed so far in this book. The radial is used in this case for the sun. The human figure is easily recognisable as one developed from a 'big head' figure. The house symbol is included. The technique used is the 'patch' painting method. The colour and paint quality .

185 'A flower and a tree'. Age 5¾ years. 22×28 in.

reflect the pleasure which the child experienced in expressing colour for colour's sake, in the sensual delight of laying paint on the paper; and the child's sense of pattern is not missing. Look at the 'decoration' of the front of the 'lady's' dress; what a rich texture of colour this produces.

186 Age 6 years. Top 11 × 15 in. Bottom 11 × 15 in.

Fig. 186 The first of this pair of paintings, 'The house', was painted by a small girl just after she had joined a school where 'family-grouping' is practised. Previously she had been attending another school where the teaching was regimented and formal. The second of the two paintings was painted by the same child after about ten days in her new school where the children are encouraged to be free and to explore and experiment. Her choice of colours was the same in both paintings. The difference between the two is in the manner of execution — between rigidity and cautiousness on the one hand and joyful freedom on the other. There is an inference to be drawn here: of the effect upon the child's mode of expression of the organisation within one school as compared with another. For this child the change of school brought liberation.

Fig. 187 This is another 'feed-back' picture. Having completed it, the child read into the painting the title 'Rain'.

The technique she employed was a very hectic kind of 'patch' painting. This child is a prolific painter and impetuous, active and full of charm.

The random pattern of dots in the painting had a 'feed-back' effect and triggered off the imagination of the child.

Fig. 188 This is a sophisticated 'radial' which the child 'read' as a spider.

187 Age 4¾ years. Play group. 24 × 12 in.

188 Age 4 years. Nursery school. 20 × 28 in.

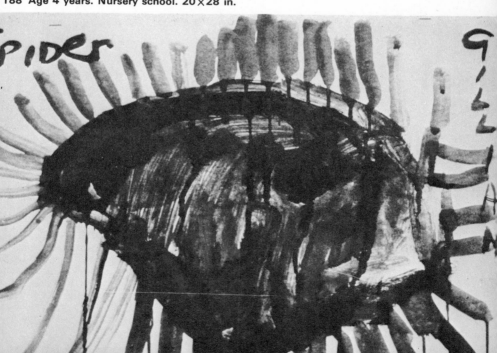

A Thunder storm

189 Age 3¾ years. Nursery class. 22 × 16 in.

Fig. 189 Stephen, aged three years nine months, produced this sensitively coloured 'patch' painting. When he had finished it he sat gazing at it for quite a while. Then he asked his teacher to write 'a thunder storm' on it.

As the reproduction shows, there is considerable evocative power in the colour. From the paint to the child there was a powerful 'feed-back'. In the child's mind the coloured patches of paint were translated into terms of vital remembered experience: thunder storm and the elemental forces of nature.

This is an extreme example of a particular kind of experience which can be provided for the child *only* in painting.

190

Fig. 190 Very young children are attracted, visually, by the shapes of letters, even before they know what the marks stand for. They often use them, just as they use other drawn shapes, to make patterns; and they frequently incorporate letter forms in their paintings and drawings because they 'look nice', a circumstance the teacher is not slow to make use of. Figs 190 to 193 all underline the point just made. 'Tibs' was described by the child as a picture.

I recall the occasion in a classroom when a boy of six was brought to a halt by the word 'village' at page 9 in his reading book. His teacher turned back to page 5 where 'village' had occurred previously. The boy recognised it instantly in its earlier context. Spelling out by rote was not used. The teacher said, 'They recognise words by their shapes; in this instance in a known context.' The *pattern* of the word was meaningful. The letters alone were not.

Writing is drawing. Drawing is writing. Writing is words, is line.

191

192

193

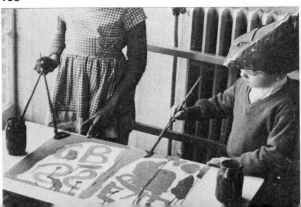

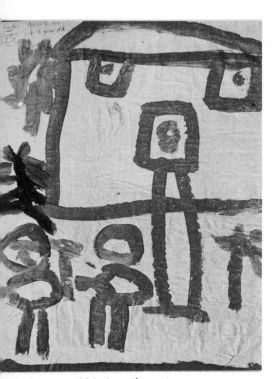

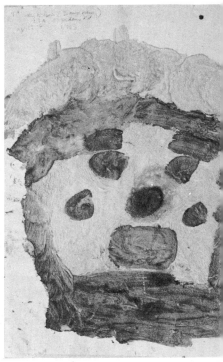

194 Age 4¾ years.
Nursery school. 28×22 in.

195 Age 3½ years. Play group. 16×12 in.

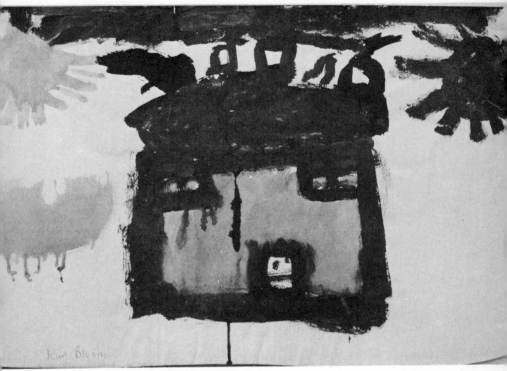

196 Age 4 years. Nursery school. 15×22 in.

Figs 194 to 196 An indicator of the half real, half dream world in which very young
children live is the interchangeability of the symbols they use in drawing.
As we have already seen elsewhere in this book, the same symbol is made
to serve many purposes. Another side of the coin is the way in which a
symbol will change its meaning and its form even while it is being painted.
Examples of this are to be seen in figs 194 to 196. What begins as a 'house'
ends up as a 'man'! We saw an incipient example of this earlier, in fig. 66.
A young mother told me how Angela, aged two years nine months, wanted
to draw and was given oil crayons and paper. She asked, 'What shall I
draw?' Her mother wisely replied, 'I can't think of anything, can't you think
of something to draw?' Angela thought for a minute and then said, 'I'll do
a house.' Later her mother asked her to tell about her drawing. The child
said, 'It's a funny face.'

Fig. 197 This unselfconscious yet highly organised and poetic picture is one of several reproduced in this book which shows the astonishing creative ability of some of these young children. It is in brush and black paint.

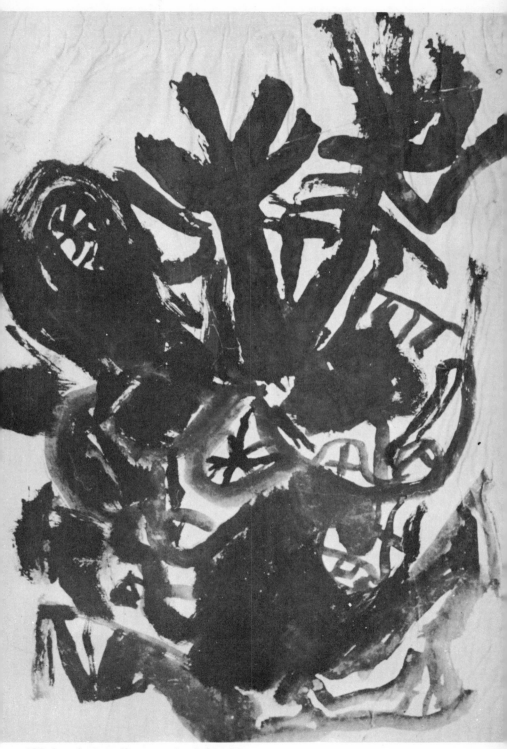

197 Age 4 years. Nursery school. 24×20 in.

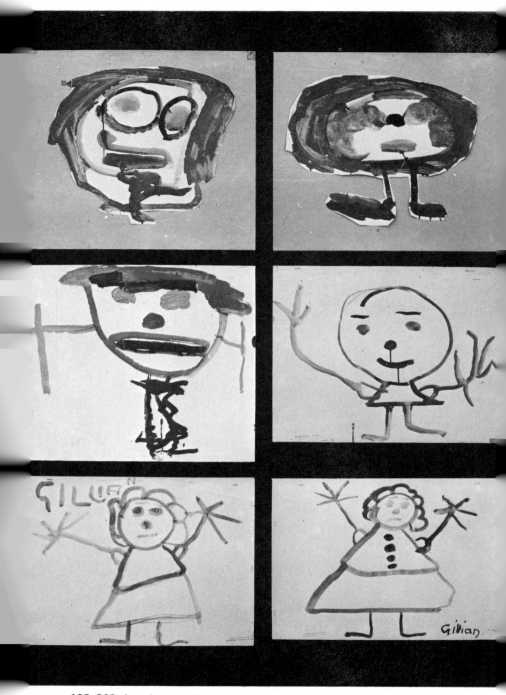

198–203 Age 4 years. Nursery school. Each picture 15×22 in.

Figs 198 to 208 These paintings/drawings form a sequence covering one term's work of one child in a nursery school. They were all painted by Gillian, aged four years.

There were periods of perhaps days when the pictures tended to be repeated time and again. The eleven examples show the various stages through which the child passed and her development and progress in

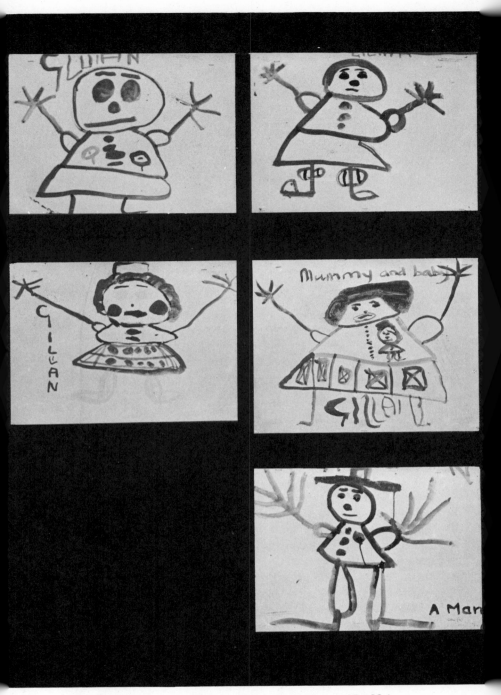

204–208 Age 4 years. Nursery school. Each picture 15×22 in.

drawing and painting her experiences over that time. Each example is representative of a phase. Study of the drawings shows how at one moment Gillian is interested in hair; at another she is absorbed with fingers; at another with clothes and again with decoration on clothes.

All the drawings are approximately 15×22 in.

Conclusion

The revolution in thinking about the creative art of young children which began in the first decade of this century is a slow and continuing revolution. It is also an incomplete revolution. There are still pockets of reaction – schools were outmoded, restrictive practices, stencils, copying, painting by rote, and the rest, still continue – though these are diminishing all the time. The revolution is world-wide, and the degrees of completeness vary from country to country.

One can safely say, at last, that the pioneering days are over. There is still need for initiators, perhaps more need for consolidators, but the greatest need of all is for research into creativity in all spheres of education, and especially the creativity of the young child and its relevance to all his other activities.

A beginning could be made to this vital work by establishing research fellowships for the purpose. Some universities, Nottingham for instance, are already engaged on research work in this field. Many education authorities have amongst their teaching and lecturing staffs men and women with the right intellectual background, experience and interests who, if granted sabbatical leave with salary, would be capable and eager to develop research into the creative expression of the child. It might well be possible to operate a relay system with new research workers coming forward year by year to take over where others leave off.

The areas for research are numerous. I would give first priority to a study of teacher training, with special reference to the amount of time each student teacher devotes to the creative and expressive arts and to acquiring an understanding of their educational function and potential.

I would like to see a scheme of research into teacher/parent co-operation and understanding, aimed at helping the parent to appreciate the nature of the creative work the child carries out at school, and so avoiding the damaging effect of the parents' uninformed and incautious comment about the work brought home by the child.

Do we know enough about environmental influences? It would be valuable to make a controlled study under scientific conditions of the creative output of a group of children whose backgrounds are known.

Is there a parallel between 'single word' expression and 'single symbol' expression?

Are some of the techniques which are devised to teach other school subjects, i.e. 'number', inimical to the growth and development of the 'individualness' of the child. I am thinking of 'number shapes'. Squares and triangles are good 'number' but are they inhibiting to creative art? Do they provide a situation in which, for instance, all the children's houses are the same because they have been made by sticking the same sort of triangles and squares together and calling them houses.

How far is graphic expression (drawing and painting) linked with spoken vocabulary? If a child does not know a word, would he nevertheless draw a symbol meaning that word? What correlation is there?

Do we make the best use of a child's visual interest in letter forms? Do we

consider the making of letter shapes and the approach to writing as part of the child's instinctive interest in 'pattern'? Do we see these as aesthetic? Is our present system of teaching writing frustrating and confusing to the child? Would it not be better to begin and continue with one form of calligraphy, i.e. the italic hand?

There is need for study, controlled experimentation and research in the field of creativity in education. Evidence must be recorded and presented in acceptable and understandable form. It must be evidence which will stand up to the same scrutiny and analysis as the evidence put forward in support of other disciplines. My hope is that this book may perhaps help to stimulate interest in the need for scientific study and experiment in this field.

Finally, may I make a plea to everyone who has to deal with young children. Do not inhibit them. Do not overlay them with adult prejudices or misconceptions. Let them be themselves. Look again at the illustrations in figs 81–3, 175, 183–5 and 197. I believe every one of these to be a 'good' work of art. In comparison with the existing 'norm' of performance at infant level these works are exceptional; but I feel certain that creative work of this quality is not really exceptional, but that it stands out as such because it is genuinely uninhibited and uninfluenced by any adult. Other work, not necessarily in this book, which suffers by comparison, has to a greater or lesser extent, either wittingly or unwittingly, been influenced by some well-intentioned adult.

There is one school I know well which is a continuous source of high-quality painting and drawing. This rich flow is not due to the influence of any one teacher. I asked the Headmistress if she could tell me how it is done. Her answer was, 'I ask my staff to make sure there are plenty of easels with paper clipped on, and plenty of paint richly mixed. We then leave the children to get on with it. We never stint as to paint; and that's all we do.'

Further reading

Language and Thought of the Child by Piaget. Routledge and Kegan Paul, London. Meridian, N.Y. (paper). First published 1926

The Psychology of Children's Drawings by Helga Eng. Routledge and Kegan Paul, London. Harcourt, Brace, N.Y. 1931

Child Art by Wilhelm Viola. University of London Press, London. 1942. Verry, N.Y. 1944

The Meaning of Art by Herbert Read. Faber, London. 1942. Pitman, N.Y. 1951

Children as Artists by R. R. Tomlinson. Penguin, London. 1944

Art and the Child by Marion Richardson. University of London Press. 1948

Education and Art. A Symposium edited by Edwin Ziegfeld. U.N.E.S.C.O. 1953

Education Through Art by Herbert Read. Faber, London. 1953. Pantheon, N.Y. 1949

What Children Scribble and Why by Rhoda Kellogg. National Press, Palo Alto, California. 1955

Primary Education. Her Majesty's Stationery Office, London. 1959

Your Child and his Art by Viktor Lowenfeld. Macmillan, N.Y. 1963

Creative and Mental Growth by Viktor Lowenfeld and W. Lambert Brittain. Macmillan, N.Y. Collier Macmillan, London. 1964

The First Year of Life by René Spitz. International Universities Press, N.Y. 1965

The Plowden Report. Her Majesty's Stationery Office. 1967

Societies, associations and organisations interested in the drawing, painting and creative work of young children

Society for Education through Art
 29 Great James Street, London, WC1
Nursery Schools Association of Great Britain and Northern Ireland
 89 Stamford Street, London, SE1
Society of Assistants Teaching in Preparatory Schools
 Mapledene, Ringley Avenue, Horley, Surrey
Royal Drawing Society
 6 Queen Square, London, WC1
Pre-school Play Groups Association
 28 Commercial Street, London, E1
One O'clock Clubs (for under-fives); Play Parks (five years upwards)
 Cavell House, 2A Charing Cross Road, London, WC2
Evening Institutes. Some institutes run courses which include lectures on the art work of infant children
National Exhibition of Children's Art, organised annually by the *Sunday Mirror* and held at Royal Institute Galleries, Piccadilly, London, W1
Society for Italic Handwriting
 41 Montpelier Rise, Wembley, Middx

Acknowledgements

A large number of people have helped in compiling this book. I offer grateful thanks to my wife Norma, who provided encouragement when it was needed, and understanding at all times. In addition she willingly undertook a considerable share of the donkey-work: proof reading, compiling of index and the like.

I am indebted to Mrs Patricia Kidd, tutor to London play-group courses, for reading and advising on the text and for unselfishly providing some valuable examples of art produced by her own children. Mr John Kenway, Senior Lecturer in Education at Coloma College of Education, West Wickham, Kent, also read the manuscript. I am grateful to him for wise suggestions and helpful references, and to Dr I. M. Marks of the Maudesley Hospital, London, for the reference to the work of René Spitz.

Head teachers, teachers, play-group leaders, friends and members of the family collected and lent many of the paintings and drawings; I am grateful to all of them for making these available. Most of all I should like to thank the girls and boys for creating the paintings and drawings.

Finally my gratitude to Mrs D. Bonnin and Mrs Eileen Moore for their skill in deciphering and piecing together my longhand manuscript and rendering it into legible typescript; and to Clark's Cameras Limited, West Wickham, for patient attention to my singular photographic requirements.

All the illustrations of children's work included in this book, with the exception of the 'progressions' diagram (pages 28–29), are photographs of untouched, authentic, 'originals'.

Index